RARE ORCHIDS

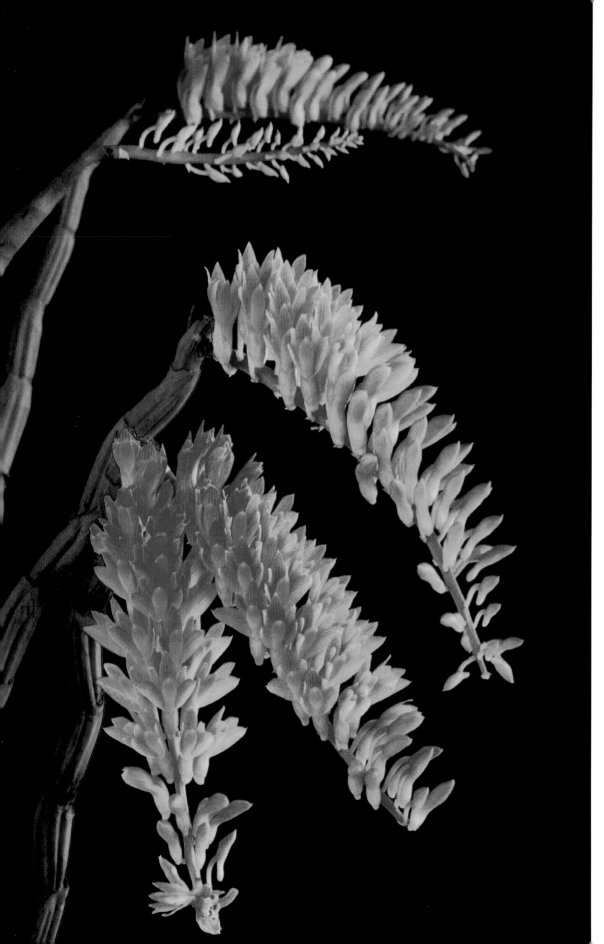

Dendrobium secundum
is widespread throughout Southeast
Asia, Burma (Myanmar), and the
Philippines, with dense flower clusters
that grow in an unusual upright posi-
tion from the top of the previous
year's canes. The blooms can be
deep pink to a darker purple, with a
waxy contrasting mark of orange on
the lip. Mature plants in nature
can weigh as much as two
hundred pounds.

With its green tints and drooping tepals, fragrant
Brassavola cucullata
has a Faustian appeal. It is found in nature at
altitudes of 6,000 feet in mountain rain forests of
Mexico, Venezuela, and the West Indies. This
was the first species described in the genus
Brassavola, which was named after a nineteenth-
century Venetian scholar; many European noble-
men of the time supported professional orchid
collectors in order to have their own names
enshrined in botanical Latin.

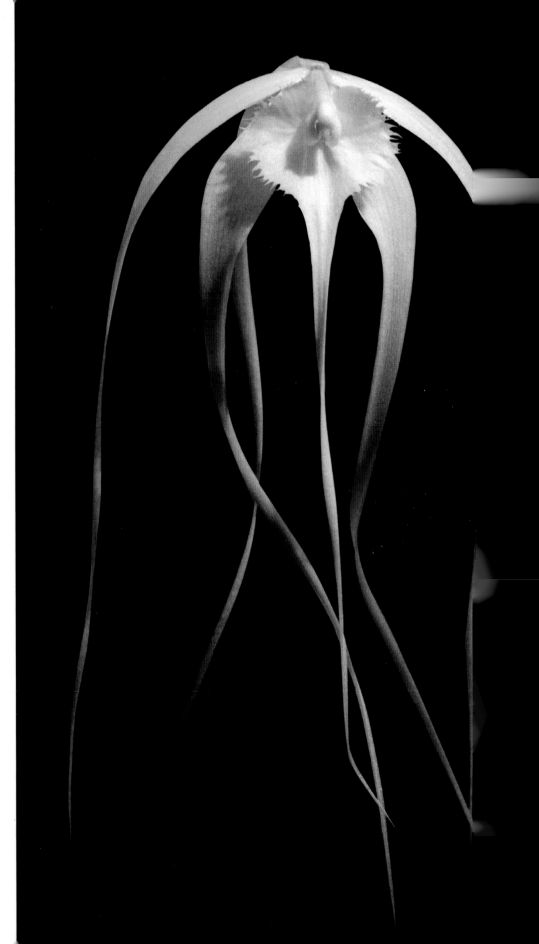

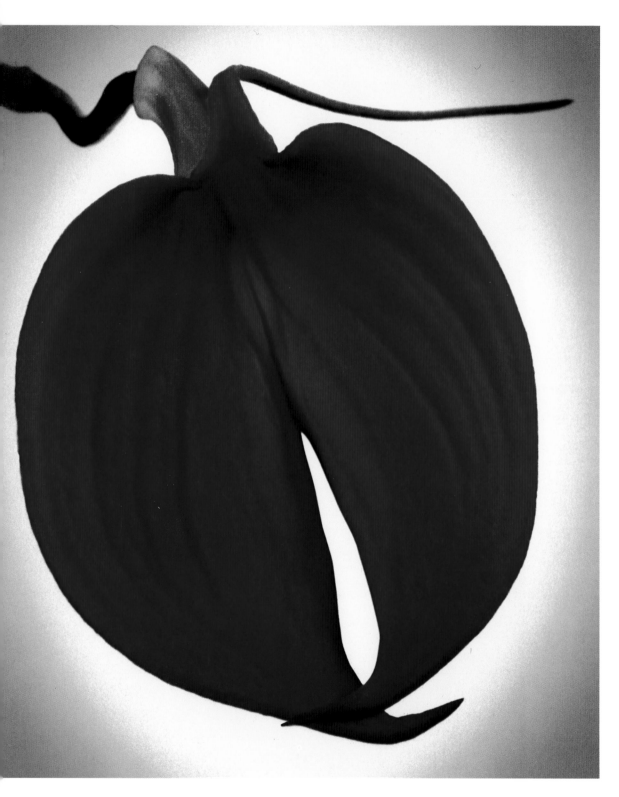

Total eclipse of "planet orchid." Exaggerated sepals of *Masdevallia coccinea* obscure its petals and lip in this atypical genus. Native to Colombia and Peru, it is justly prized for its solitary bright flowers.

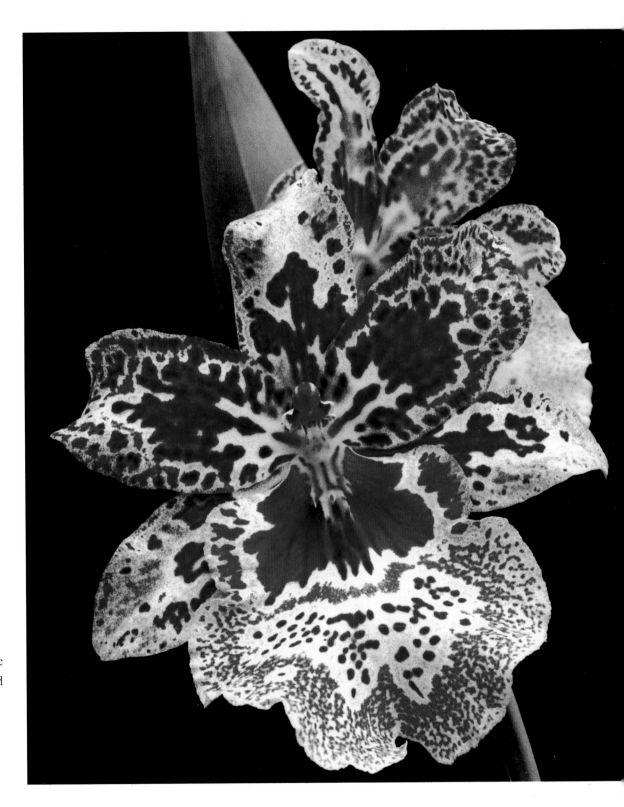

This spectacular freckle-face is hybrid *Odontonia* Susan Bogdanov, which displays the colorful flat face of a miltonia with the spotting and markings of an odontoglossum. Usually, one genus dominates a cross; this is a good example of a hybridizer balancing the desirable qualities of both parents.

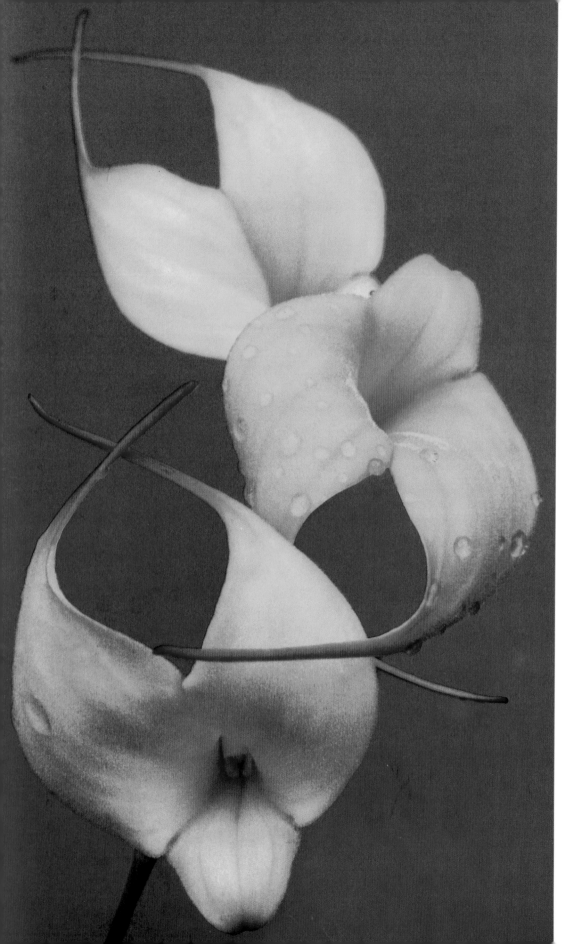

Triumvirate of gilded
Masdevallia 'Copper Angel'
blooms hover in a blue sky. Dwellers
of tropical high-mountain forests,
colorful, miniature masdevallias are
compact in growth, need filtered light
and cool temperatures, and should
never be allowed to become dry.

The insectlike coloring and form of
Psychopsis limminghei
attract pollinators and appreciative
connoisseurs alike.

Overleaf and page 11:
Laeliocattleya Sultan ×
Cattleya guttata.
Subtle synthesis of red and green
marks this waxy, long-lasting cross, a
novelty that blooms in late summer
with the fragrance of cloves.

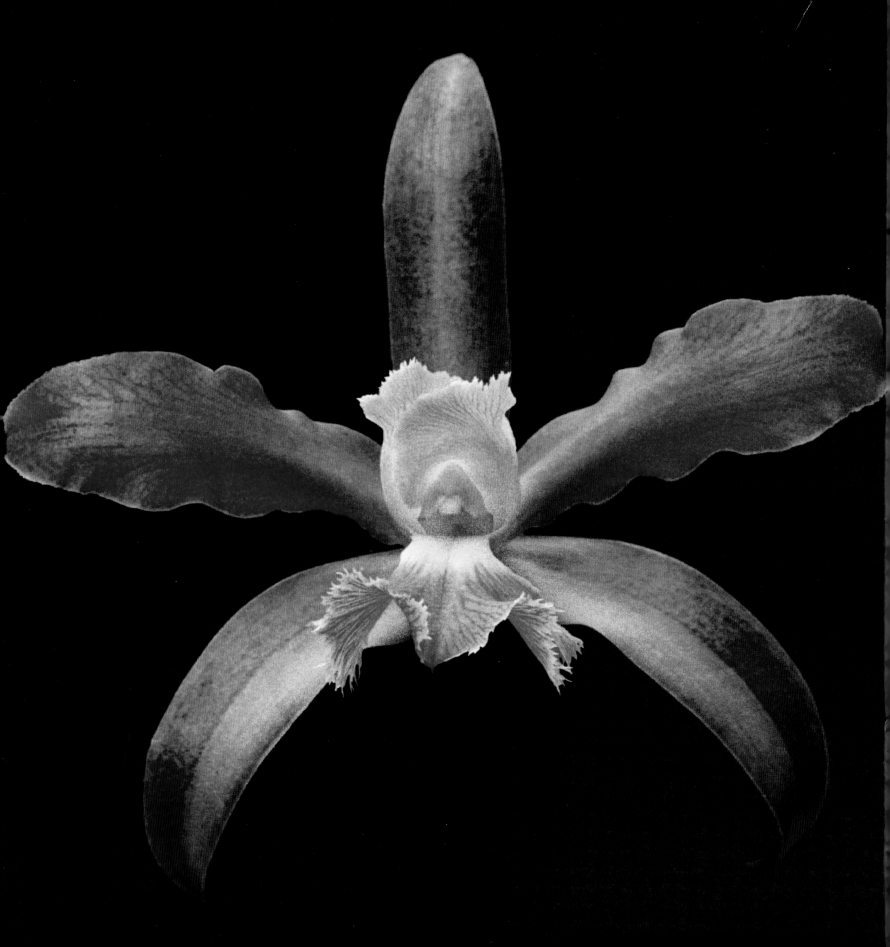

RARE ORCHIDS
Photographs by Béla Kalman
Text by Rosalie H. Davis and Mariko Kawaguchi

A BULFINCH PRESS BOOK / LITTLE, BROWN AND COMPANY

BOSTON NEW YORK LONDON

For my wife, Edna

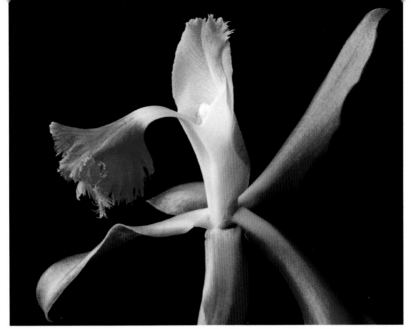

Photographing rare orchids drew me into a world of beauty I had never known before. Just look at the variety of designs, sizes, and shapes — it mystifies you, tickles your sense of beauty, and makes you want to own every one of them! It is quite a challenge to make the photographs, because orchids bloom mostly in winter and the peak lasts only a few days. When I began this project I had no idea what a vast world the orchid empire is. There are many people worldwide who spend a lifetime in propagating, researching, and handling these beauties. It is not easy to grow orchids in captivity; a lot of care is needed. Their commercial use is a fantastically rewarding business, but it is their mystique that makes people want to grow and hybridize them, searching for them in remote places of our planet. The delicacy of the design and richness of color mesmerize and urge one to do more and more research to produce ever more exotic species. The science connected with the growing process is admirable, spreading from one generation of growers to the next. By now there are hundreds of years of history and cultivating secrets to pass on. New hybrids are born daily; no one knows them all. The 6,000 plants I photographed for this book over a period of three years were narrowed down to 600, and then an expert panel selected the 140 photographs included in this book. These examples of rare orchids are the tip of the iceberg, but they show the diversity and mystique of Mother Nature's delightful, joyous creatures.

Béla Kalman

The Mystique of Orchids

The flowers photographed for this book all belong to the Orchidaceae, one of the largest families of flowering plants on the face of the earth, and easily the most diverse. Botanists have described some twenty thousand species and sorted them into an estimated one thousand genera — so far. Remarkably, as many as one out of every ten types of flowers may be an orchid.

Orchids are cosmopolitan; in every climate that can sustain a green leaf — and in some places that cannot — there is an orchid that has found a niche. Such are the infinite adaptations these unique, sophisticated flowers have made to the many vagaries of sun, soil,

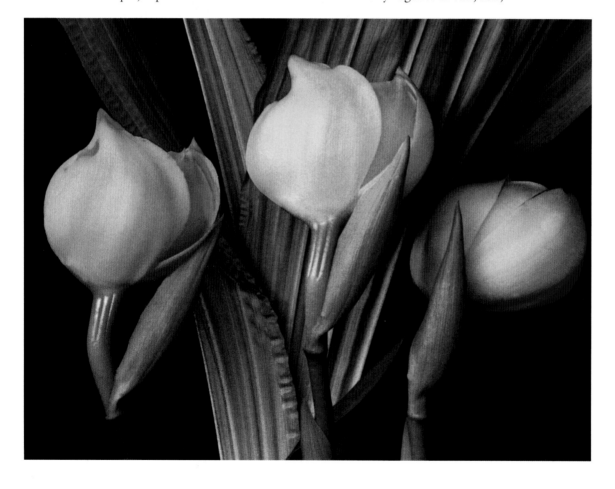

Angulocaste
Sandy Murphy
'Raquel'
is a man-made hybrid of two closely related genera, *Anguloa* and *Lycaste,* which grow in cloud forests in Latin America.

moisture, wind, and available pollinators that it is impossible to characterize them as other than exceptional, curious, and rare — no matter how abundant they might be.

Every region has its orchids. There are species that grow on coastal sand dunes and others that find a foothold on the cliff faces of high mountains. They grow in boreal bogs of the subarctic, on rocks in swift tropical rivers, in temperate meadows and equatorial savannahs, in the mossy ground of sun-dappled forests and high in the treetops of the deepest jungles. One species even grows and flowers underground, without sunlight or pollinator.

As is often the case, the greatest diversity and abundance of species within the family is to be found in the moist tropics. Central and South America, Africa, and India and Asia through New Guinea and Australia to the islands of the South Pacific account for more than half of the known species, and for almost all of those generally in cultivation. Yet, perhaps the best-known orchid is the North American lady's slipper, *Cypripedium acaule*. This primitive, temperate-climate terrestrial grows over much of northeastern North America, in apparently the same conditions as other woodland wildflowers. Ironically, such unassuming natives can be even more difficult to cultivate than exotics. Taking as long as fifteen years to flower for the first time when grown from seed, sensitive to the slightest environmental change, the common lady's slipper, not surprisingly, has until recently eluded successful propagation and transplanting.

Since orchids are such a far-flung family, it follows they have evolved numerous adaptations to get along in so many locations. Their leaves are generally linear or hostalike, but they can be any shade of green, mottled or etched in a network of contrasting veins, with texture ranging from grassy to waxy, even glasslike. Some have leaves that look more like finely braided leather ropes. The muscular bulblike stems (called pseudobulbs) and velvety roots of some species provide visual appeal even when the plants are not in bloom. A few, the jewel orchids, are grown exclusively for their refined foliage.

Superlatives abound. There is one species as large as a palmetto and another that would fit in a thimble. The longest is probably the fifty-foot, vining *Vanilla fragrans* (also known as *V. planifolia*), the chief source of that most ubiquitous of flavoring agents. Native to Meso-America and known to the Aztecs, vanilla is the only orchid of commercial importance beyond the ornamental. Vanilla flowers are fragrant, large, fleshy, of greenish ivory color, aesthetically as quiet as an old-fashioned white rose. But orchids may also be any shade of red,

orange, yellow, green, violet, purple, pink, pure white, and that least likely of flower colors, true blue — and virtually any combination of colors.

Decorative markings are endless, from fine dark stipples, freckles, and warts to lacy fringes, stripes, glossy veining, or fuzzy little hairs. Some species display grotesque irregular petals, sweet tiny white bells as delicate as lily of the valley, or sprays of winged figures that resemble the moths, butterflies, bees, and wasps they wish to attract. We see in them suggestions of monkey faces, wishbones, dancing ladies, male and female genitalia.

And yet the family resemblance is unmistakable. In nontypical orchids these structures are either all out of proportion, reduced, or hidden. But they are relatively easy to see in a classic form, like a hybrid cattleya. For starters, the flower has one line of symmetry, rather than the radial perfection of a rose, dahlia, or even its closest kin among flowers, the iris. Count the petals; typically, an orchid has six. The three outer, usually more narrow, segments are called sepals. The three inner ones are the true petals. Two of these are identical and embrace the lowest petal, the lip, or labellum, the most conspicuous element of the flower and nature's design to lure pollinators to the apparatus of reproduction.

The nineteenth-century naturalist Charles Darwin devoted an entire book to the various contraptions by which orchids are pollinated by insects, a study that helped to shape our most basic ideas of evolution. To ensure cross-pollination between flowers, these resourceful plants attract insects and even a few birds, bats, and frogs through a fascinating array of colors, textures, traps, disguises, mechanisms, and food. Fragrances range from sweet, lemony, rosy, fruity, and aromatic to musky, pungent, and odorous; some rank blooms mimic carrion and so attract flies.

Perhaps the most remarkable aspect of orchid anatomy is the entire fusion of the male and female parts into a single, columnlike structure. In most other flowers, a vase-shaped ovary filled with unfertilized eggs tapers upward into a style, ending in a porous, narrow opening receptive to pollen, known as the stigma. Separate, wandlike male anthers radiate outward from the base of the female organ, each one capped by a cluster of pollen that is loose and granular when ripe. In most orchid flowers, the male components are reduced to a cap of dense, waxy pollen, packed into a neat mass that rests directly on the stigma — essentially a single, stemless anther, the pollinium. Insects transfer the entire, intact pollen packets between flowers, thereby effecting fertilization. This sophisticated arrangement — and the highly specialized

cooperation it demands from pollinators — is unique to orchids.

For all their sensuality, orchids in nature are admirably faithful to their pollinators. *Cypripedium,* for instance, must have a bee, which wanders in through an opening in the pouch and can't escape without picking up a packet of pollen on its way out of a bee-sized door at the top of the flower. Velvety *Ophrys* so closely resembles a female bee in looks, scent, texture, and time of availability that male bees inadvertently pollinate the flower in an act botanists tactfully call "pseudocopulation."

Orchids are among the most durable of flowers, lasting months if not pollinated. After fertilization, each ripening capsule quickly moves on to the task of providing for the next generation, filling with literally millions of microscopic seeds.

Far from satisfying our appetite, scientific advances over the last two centuries in understanding and growing orchids seem only to have increased our desire for yet more varieties. As if there weren't enough orchids, we want one that blooms earlier, or later, or lasts longer. Humans, perhaps the ultimate pollinator, have made thousands and thousands of hybrids that nature never intended. Some of these crosses are between plants that live on opposite sides of the earth, some between species pollinated by different insects that are incapable of switching roles, and some simply liaisons between genera that a nectar-drunk bee could never have arranged.

Given their mystique and their endless variety, it isn't surprising that in literature orchids tend to appear in the company of the doomed, the forbidden, the unknown. They turn up in Shakespeare in Ophelia's hand; on the bosom of mistress Odette in Proust's tortured romance; and even in the mystery novels of Rex Stout as detective Nero Wolfe's exotic hobby.

As these stunning photographs of rare orchids show, there is always another lost, forgotten, or simply dreamed-of bloom to capture our imagination. And we are sure to be as inevitably attracted to it as the hapless bee that mistakes the flower for his mate.

— Rosalie H. Davis

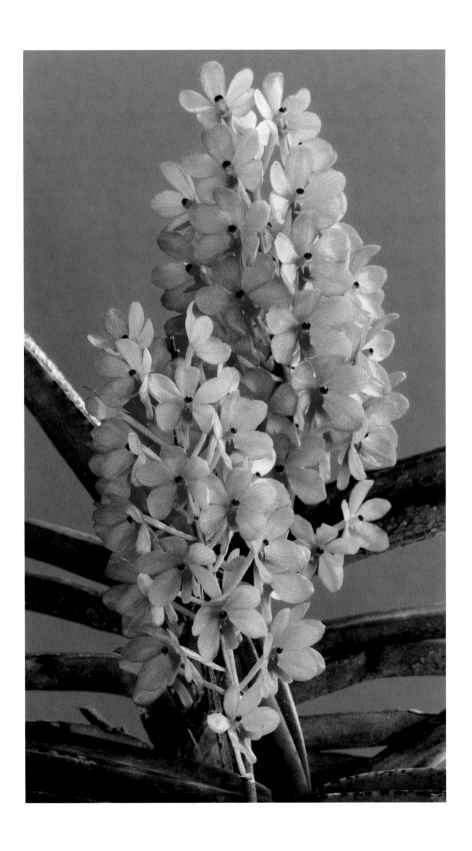

With its long-lived red-orange
racemes, the popular
Ascocentrum miniatum
makes a dazzling display. Florida gardeners
can grow this free-flowering species
outdoors mounted on trees.

◀

▶

This perfect man-made
hybrid *Vanda*
has the lovely markings of its pod
parent, *V. coerulea*, from the
Himalaya, and the rare electric blue
of its pollen parent, *V. lavoix*.
Appropriate to its India-Asia origins,
the genus name *Vanda* comes from
the Sanskrit word *vandaka*, meaning
"shelter among trees and shrubs."

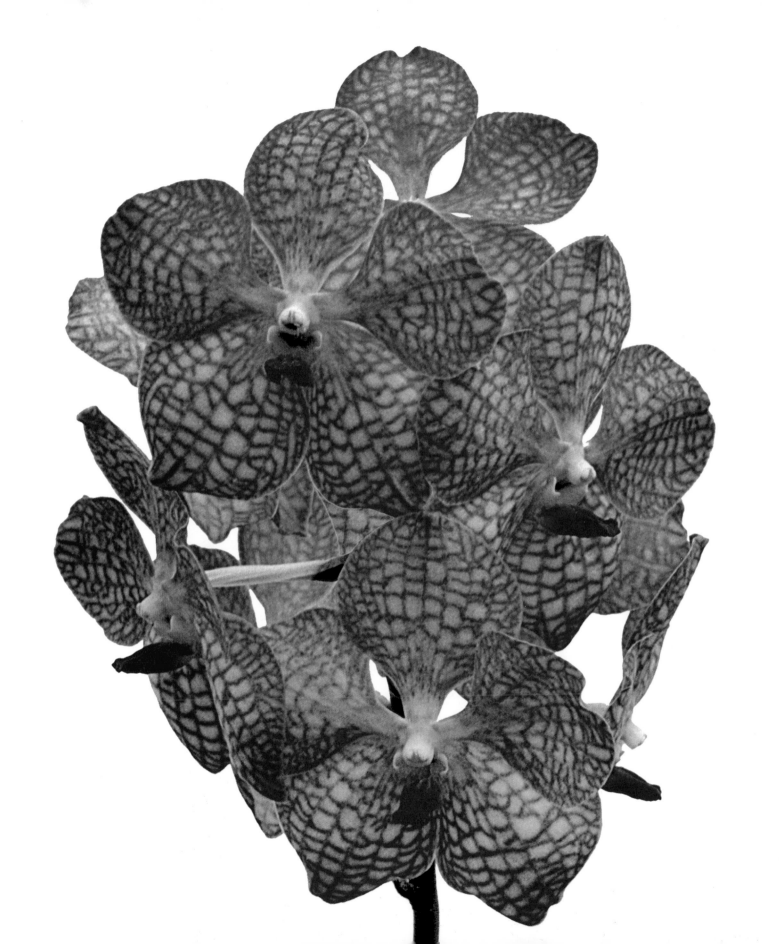

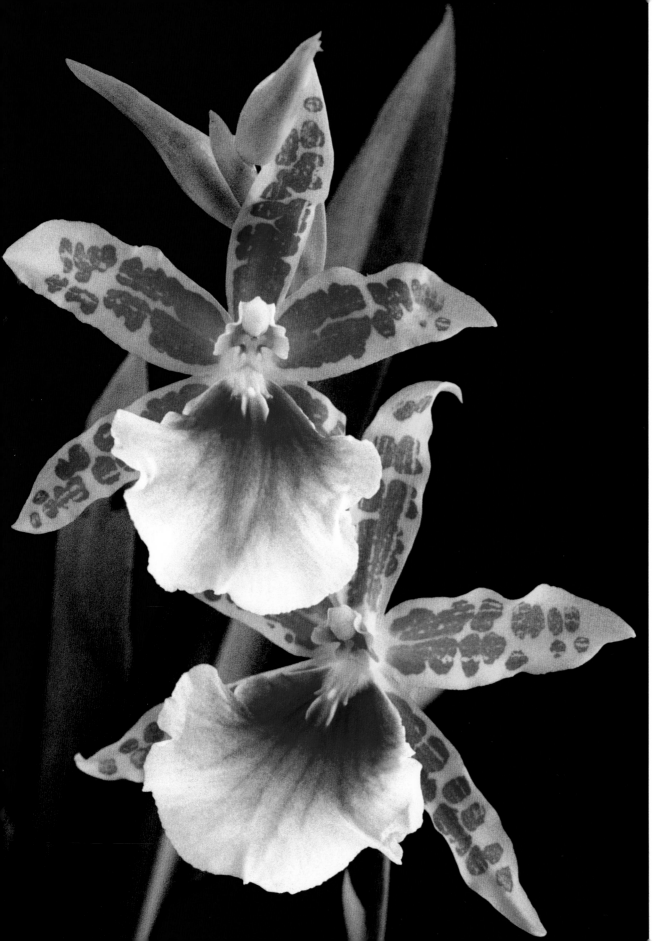

A perfect pair of
blooms of a
warmth-loving Brazilian
Miltonia
Goodale Moir,
offspring of *M. flavescens*
and *M. clowesii*.

Tree-dwelling epiphytes
like the cockleshell orchid,
Encyclia cochleata,
were misunderstood for years when they were
brought into cultivation in overheated, stagnant
"stovehouses" of eighteenth-century England.
This easy-to-grow, fragrant species defied the odds
when it bloomed in 1789 at the Royal Botanic
Gardens at Kew. *Encyclia cochleata* is a non-
resupinate species; its lip stays at the top of the
flower. (Most orchids twist around in bud, and
unfold the lip at the base of the bloom, where
pollinators find it more easily.) Its native range
extends from Florida south to Brazil.

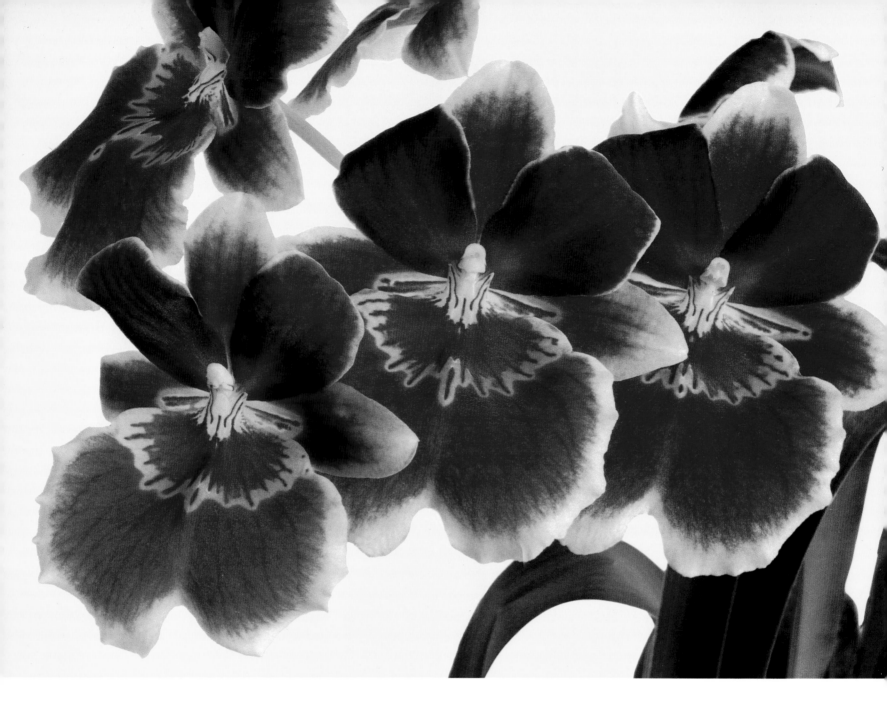

The unusual markings in the center of this pansy orchid look like
a twirling ballerina. The American Orchid Society gave this hybrid
Miltoniopsis Bert Field 'Crimson Glow'
its Award of Merit, an indication of outstanding quality. Though closely related to
warm-growing miltonias, this genus thrives in cooler temperatures and filtered light.

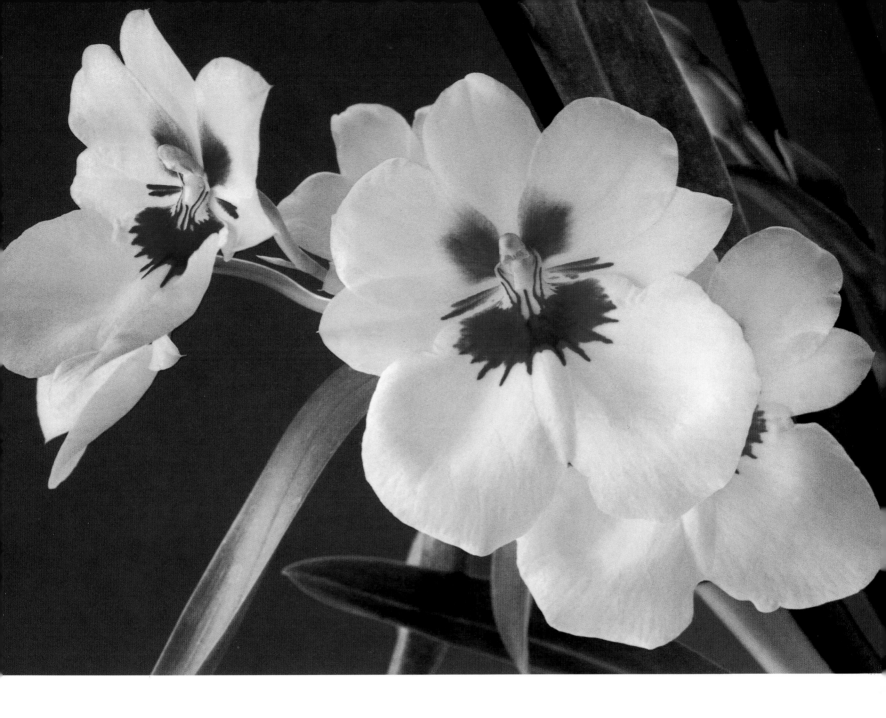

Hybrid
Miltoniopsis phalaenopsis Zorro 'Yellow Delight'
blooms prolifically — it's on the wish list of every collector of yellow flowers.
Pansy orchids like these are derived from species of moist mountain cloud forests of South America.

21

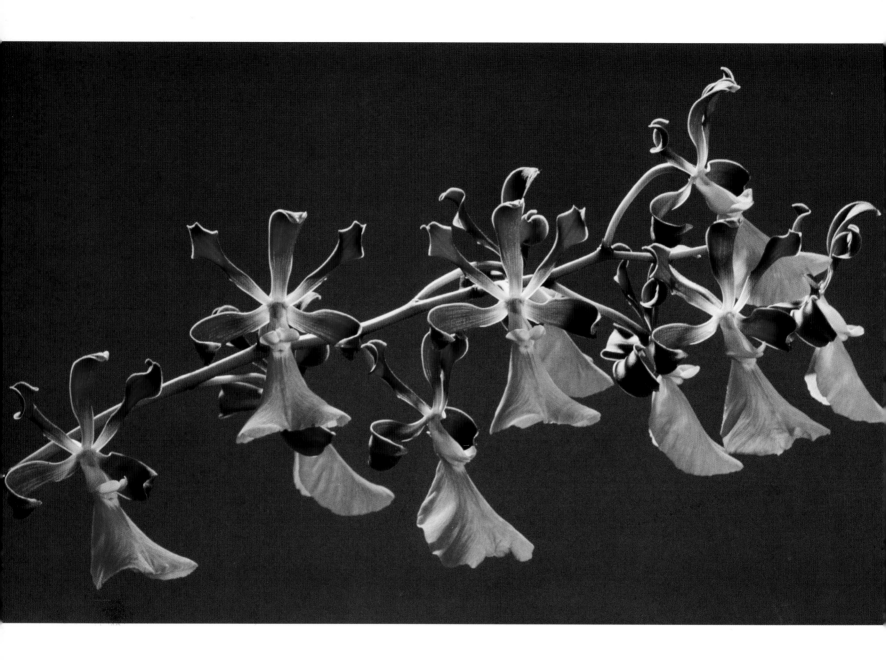

A spray of
Encyclia cordigera.
This species has lovely contrast of bright rose and deep brown,
and elegant oval pseudobulbs at base of plant. Fragrant, warm-growing,
relatively easy to flower, it grows in the same conditions as cattleyas.

22

Found in nature at middle
elevations in Mexico,
Epidendrum
veroscriptum
produces tall canes with hanging
clusters of green flowers
with contrasting red marks
on the white lip.

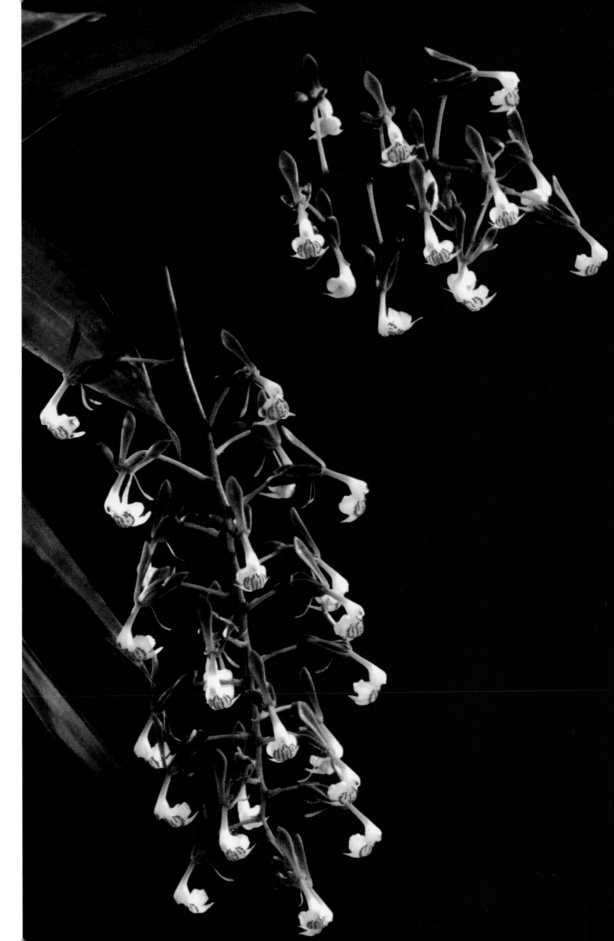

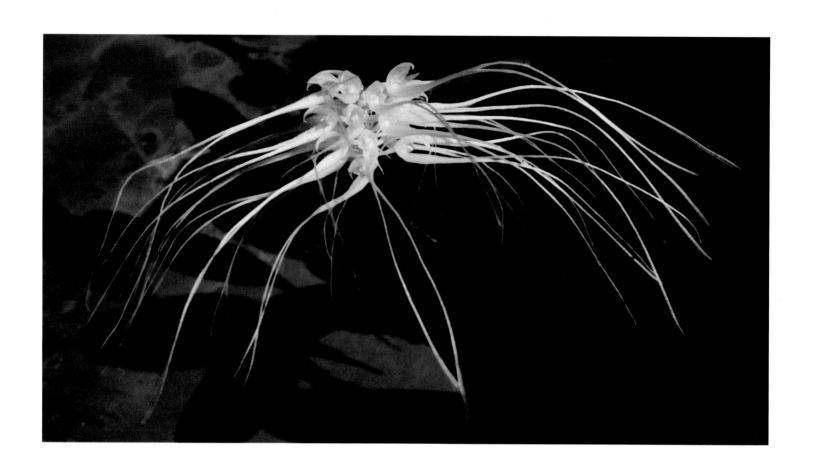

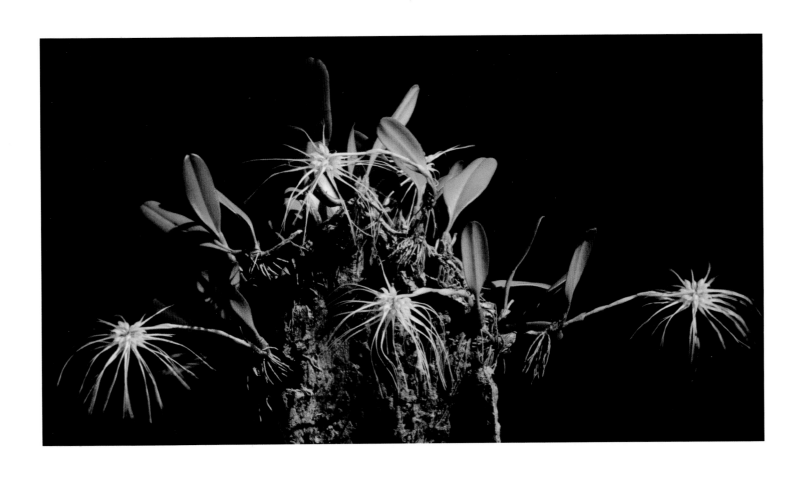

Bulbophyllum vaginatum
(opposite) has a Medusa-like appearance. Above,
the same species has colonized a cork raft.

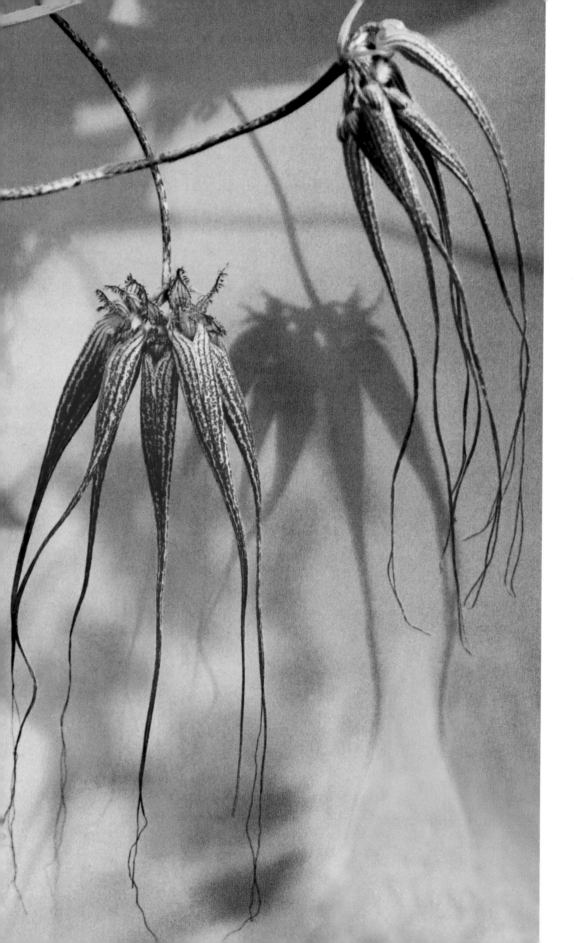

Intersecting stems of flowing, squidlike ***Cirrhopetalum rothschildianum*** blooms cast beautiful, watery shadows. *Cirrhopetalum* and *Bulbophyllum* are very similar; some taxonomists treat them as a single genus.

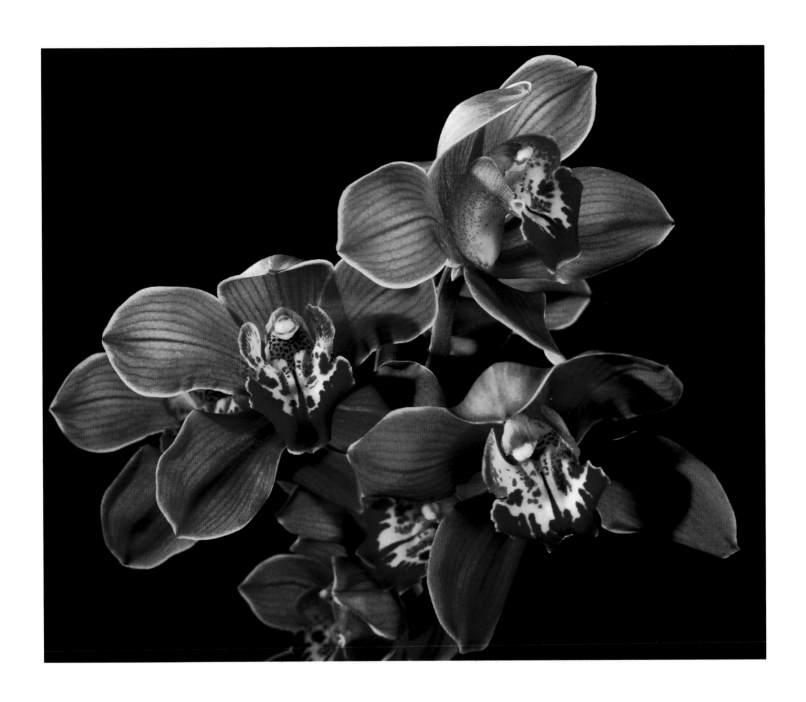

Cymbidium Red Beauty 'Carmen'
has unusual deep red coloring. It's not hard to see
why this standard-size European hybrid is an important cut flower.

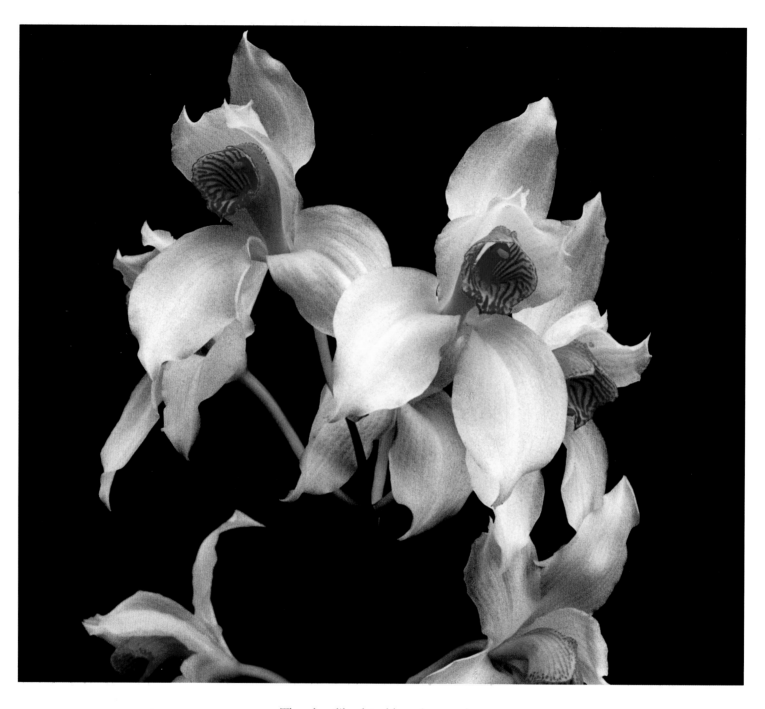

The ghostlike, late-blooming species
Cymbidium erythrostylum
is native to Vietnam. *Erythro* in the Latin rubric connotes
red, in this case a reference to the scarlet column.

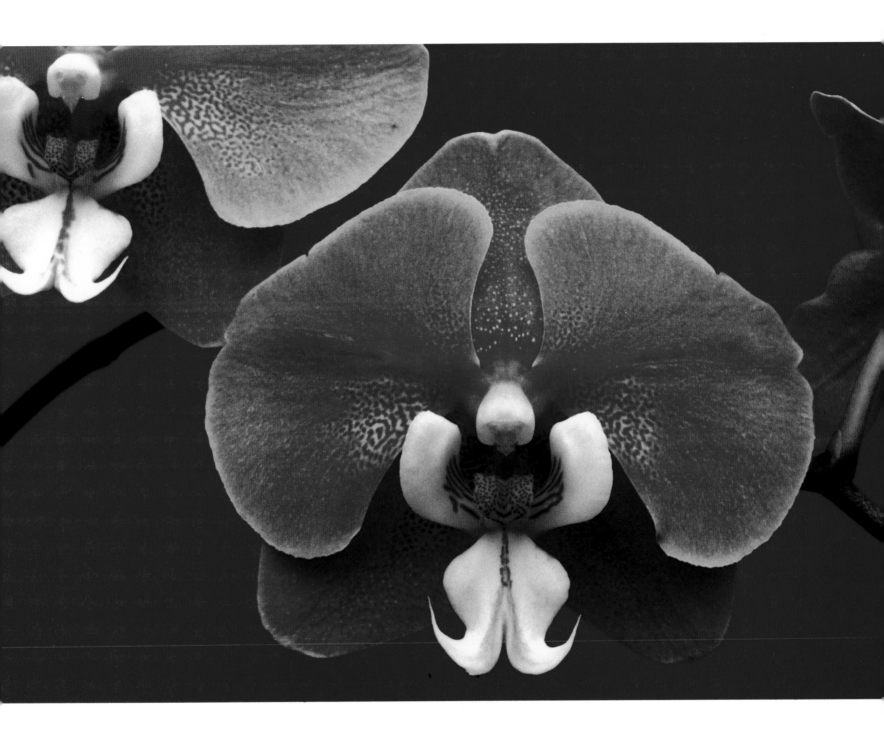

Phalaenopsis Hilo Lip 'Catnip'
is unusual for its white lip, a rare mutation and
a dramatic contrast with the dark rose background.

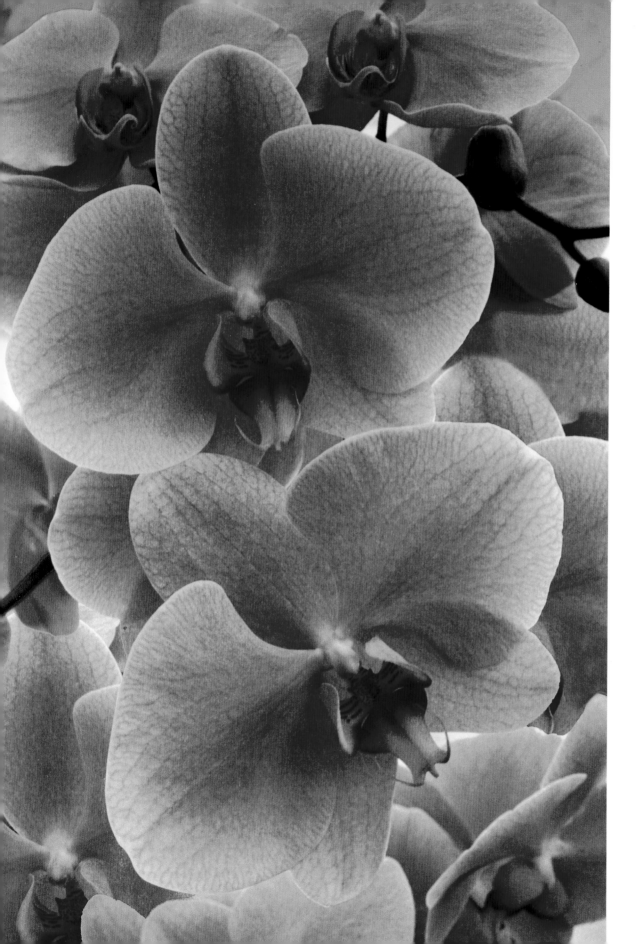

Orchids of the genus *Phalaenopsis,* the moth orchids, are native to the tropics of Asia, southward to Australia. Windowsill gardeners grow and love the many species and hybrids, easily the most rewarding orchids to grow as a houseplant — an excellent beginning to a lifelong hobby. The blooms last for weeks, even months, and plants sometimes send up a second flower spike. Phals, as they are often called, like high humidity and indirect light. With its delicate lures, this refined pink hybrid certainly gives the illusion of a flight of fairy-winged moths.

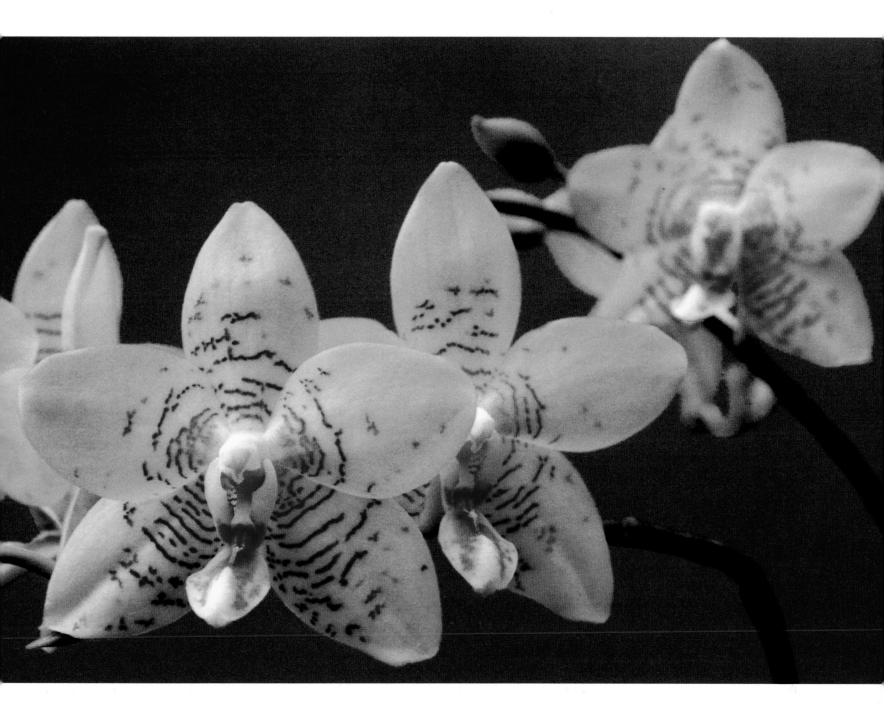

The Taiwanese hybrid
Phalaenopsis Tai Pei Gold x Maraldee
reflects the aesthetics of the Far East. It has a good, clear yellow color, rare among moth orchids;
thick, heavy substance, or feel; and multiple spikes of flowers owing to its Maraldee parentage.

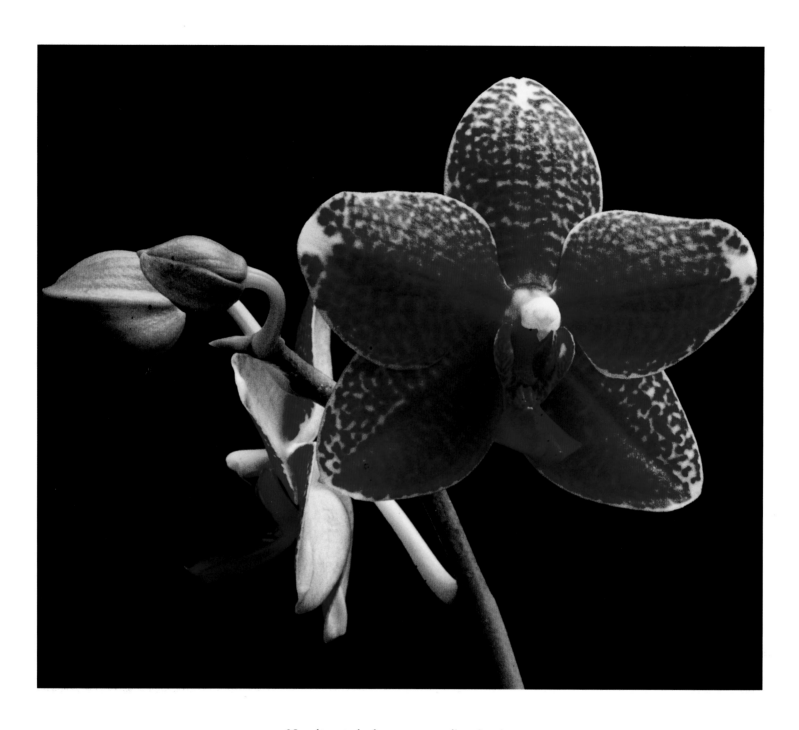

Novelty art shades are a new direction in
Phalaenopsis breeding. This rich red hybrid,
Paifang's Queen × Salu Spot,
has a saturated middle and marbling at the edge.

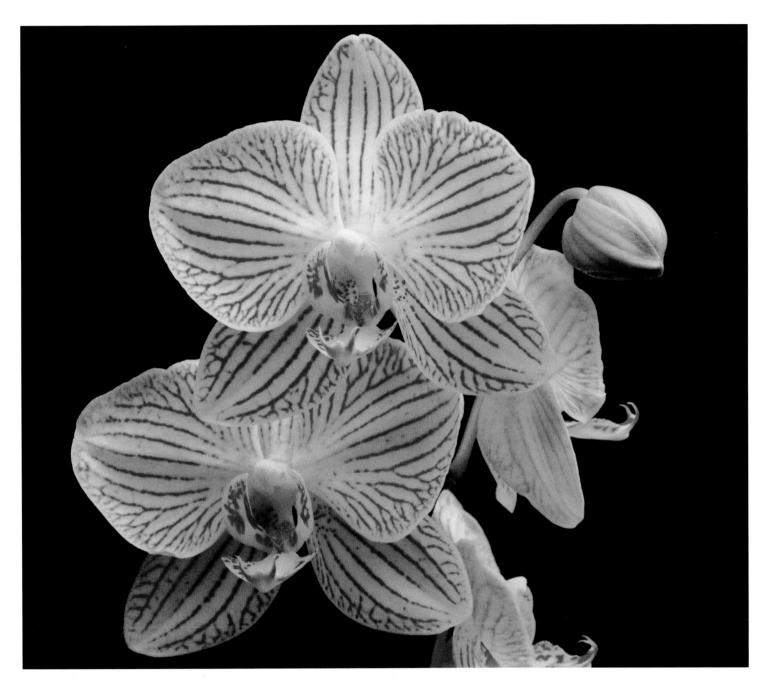

Dramatic focus and a dark background give these striped blooms the
air of acrobats under a circus spotlight. An award-winning plant,
Phalaenopsis 'Bonnie Vasquez'
holds a First Class Certificate, top honor of the American Orchid Society. Collectors prize
such best-in-show cultivars — and are happy to pay a premium for them.

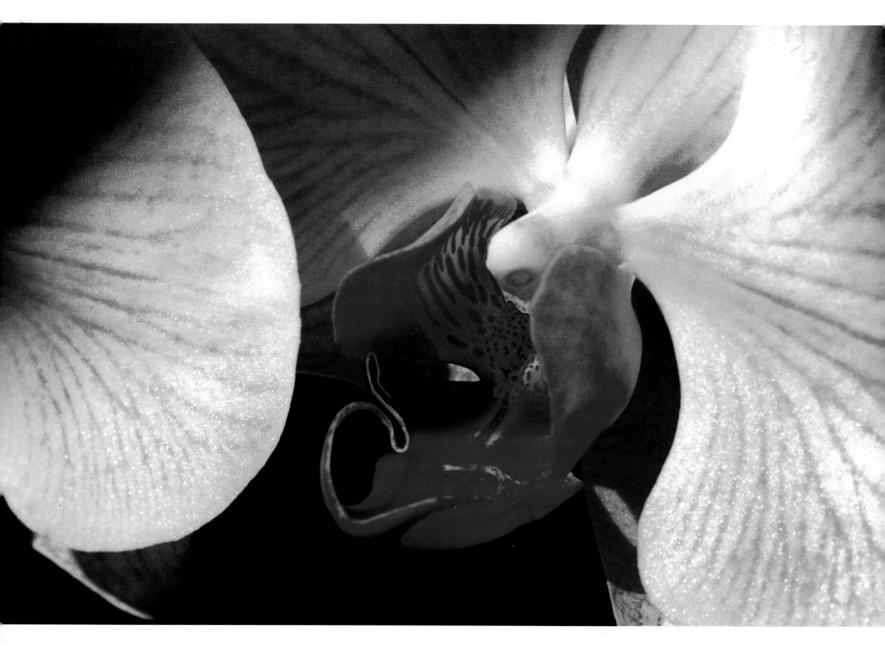

Note the face of an avenging angel in this hybrid,
semi-alba type *Phalaenopsis.*
Our fascination with the remarkable anthropomorphic
images in orchids is surely part of their mystique.

▲

Native to New Guinea and the Solomon Islands,
Dendrobium spectabile
has naturally curly sepals, and is an easy-to-grow and unusual
showpiece. *Dendrobium,* an exclusively Old World genus,
comprises about a thousand species and an astounding
6,000-plus horticultural varieties.

▶

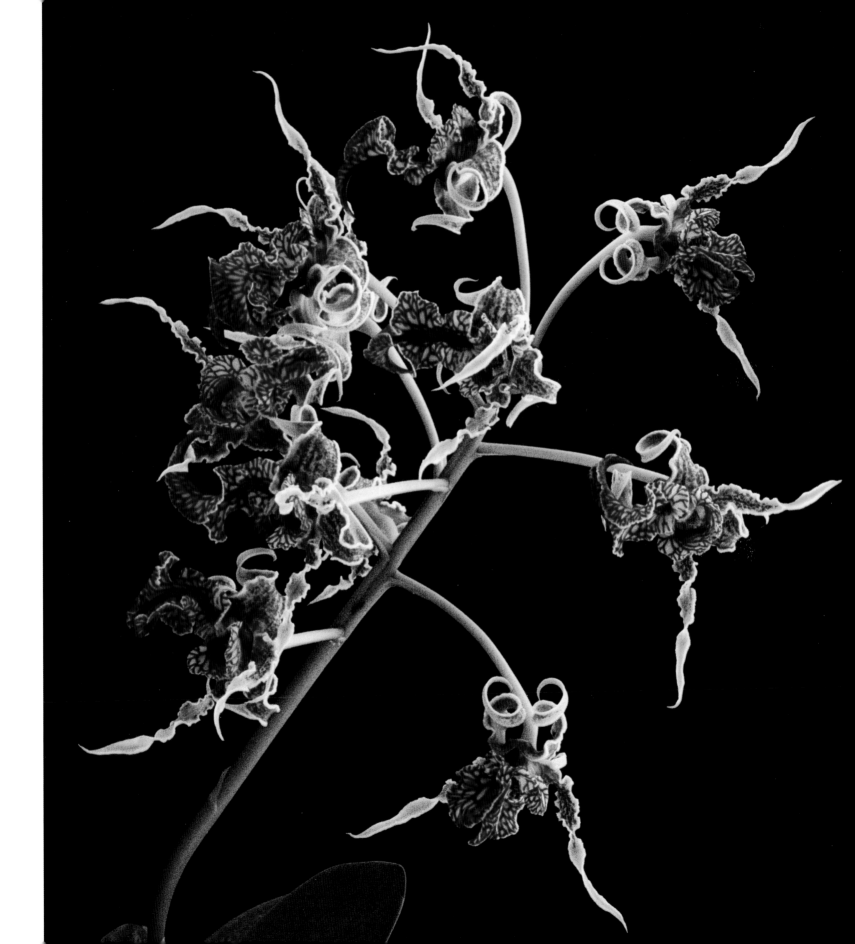

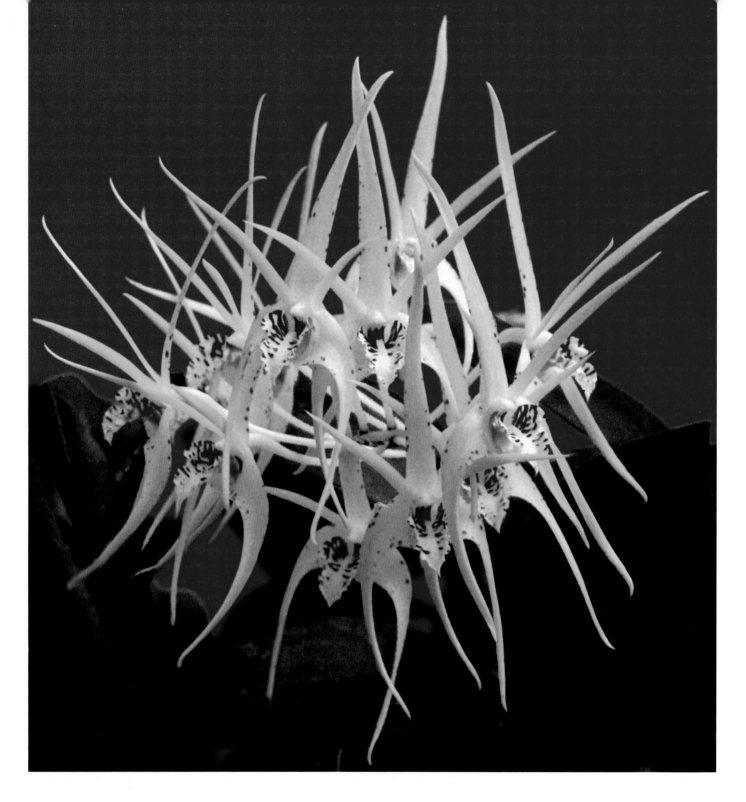

Of Australian provenance,
Dendrobium Hilda Poxon
forms a spiky, crownlike inflorescence.

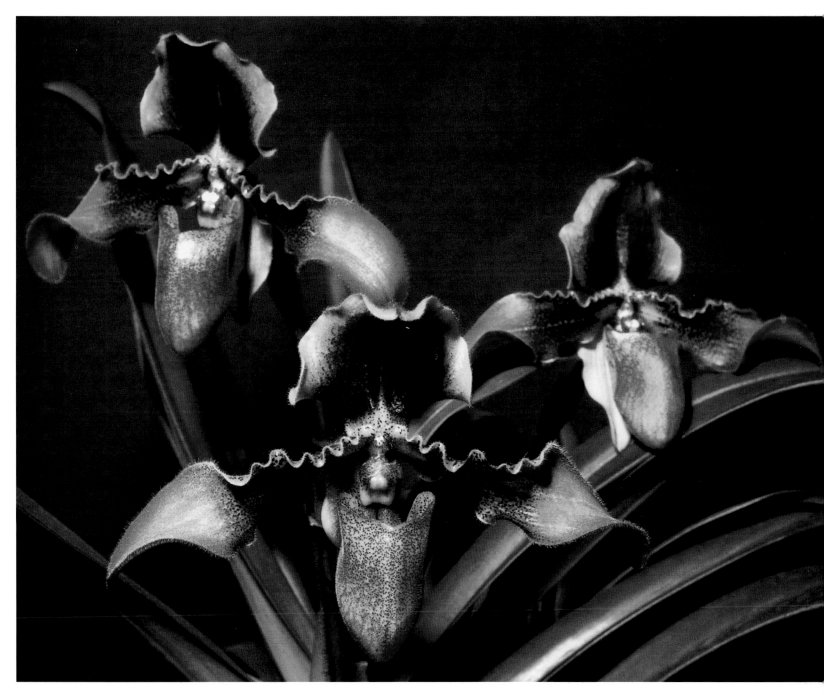

The contrast of lotus pink and jade green, plus luxuriant
velvety texture, lend the Himalayan species
Paphiopedilum hirsutissimum
the fantastic air of a flower in an Indian tapestry.

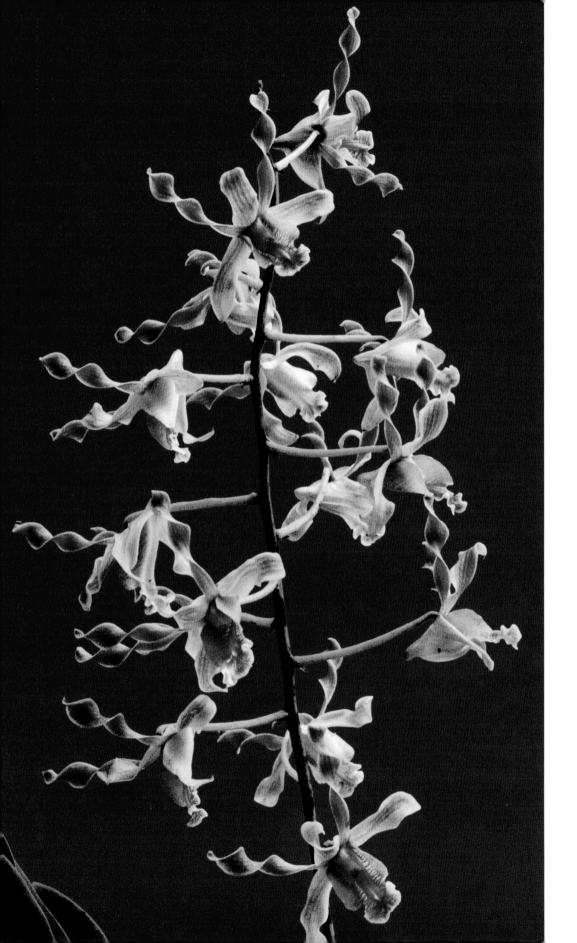

Chestnut-brown and greenish-white
Dendrobium helix
bears delightful resemblance
to pasta spirals.

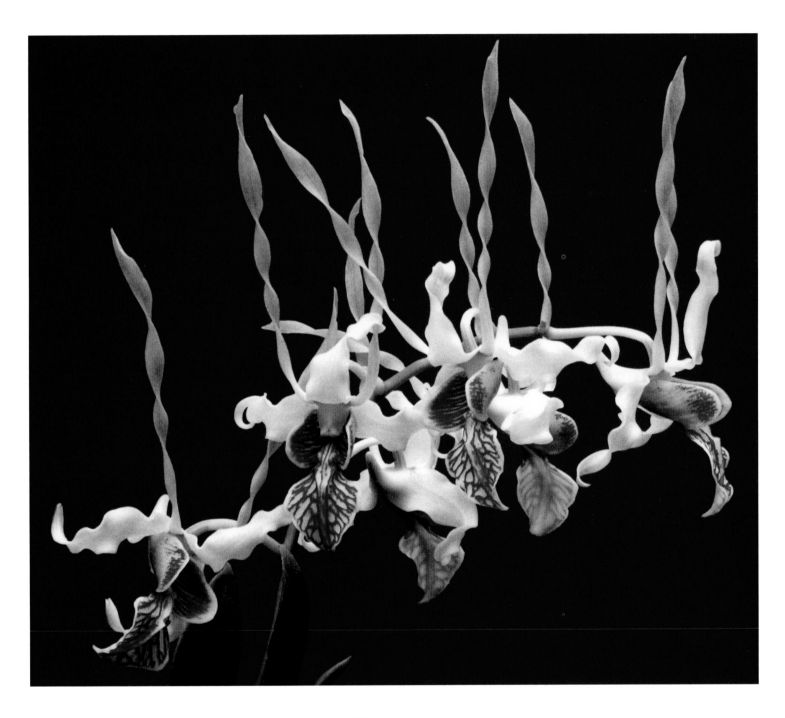

Prolific, free-flowering
Dendrobium stratiotes
sends up multiple spikes on mature evergreen plant.
This is the classic "antelope" dendrobium.

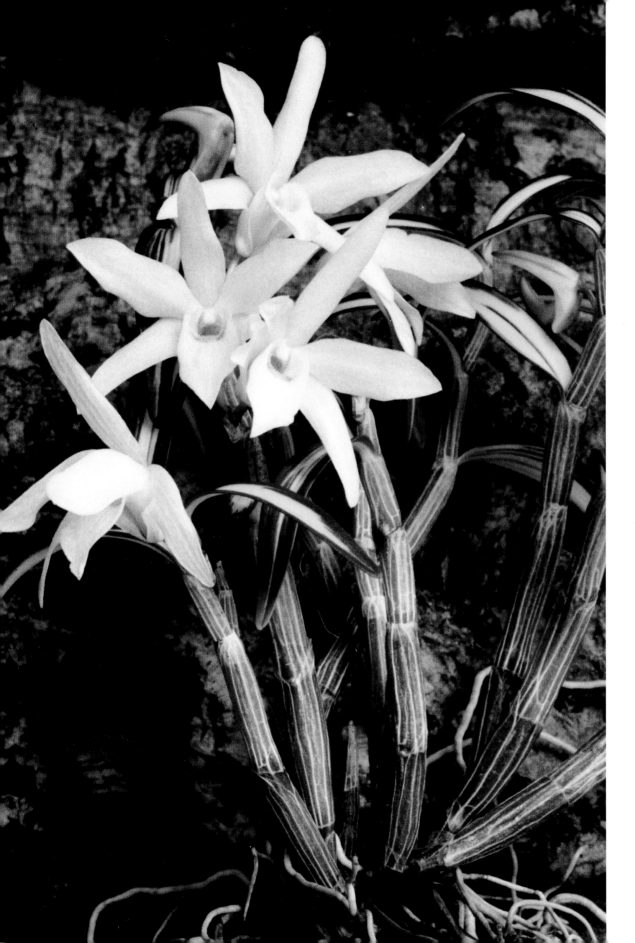

The miniature *Dendrobium moniliforme* 'Kinzan Kongah', with pure white blooms, grows less than a foot tall. Even if it never bloomed it would be prized in the Orient for the beauty of its variegated foliage and delicately striped stems. Cultivated and highly esteemed for centuries in Asia, variegated orchids often grow at a much slower rate due to the reduction of chlorophyll in the leaves. More than one hundred cultivated forms of this particular species are admired in Japan today.

The squat, tubby canes of
Dendrobium bracteosum
species produce hundreds of long-lasting tiny,
waxy blooms with orange duck bills.

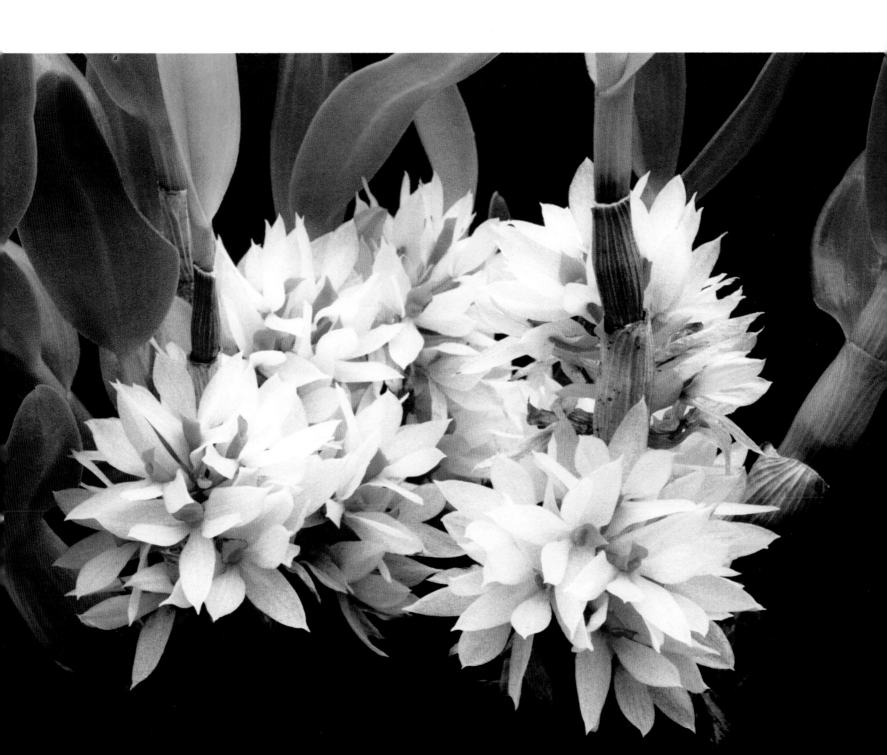

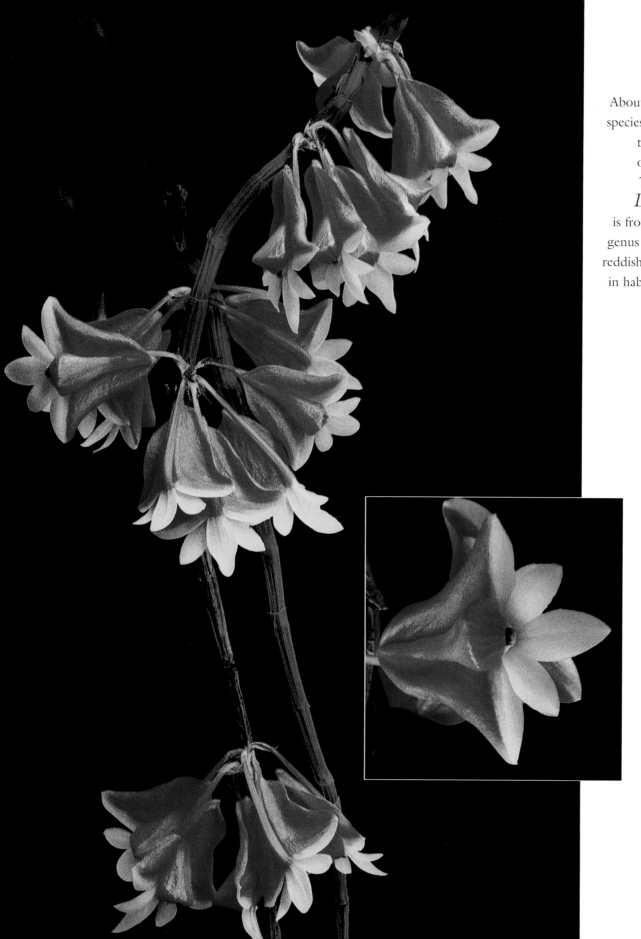

About a third of all *Dendrobium*
species are native to New Guinea,
the richest orchid flora
outside Latin America.
The plant shown here,
D. obtusisepalum,
is from a variable section of the
genus that can be yellow, orange,
reddish pink, or combinations, and
in habit epiphytic (tree-growing)
or terrestrial.

Dendrobium pierdii and
D. *superbum* were crossed
in 1892 to produce
Dendrobium Adastra,
one of the oldest hybrids in the
entire genus and a favorite to this
day. It has a fragrance reminiscent
of rhubarb, and a distinct touch of
yellow on the labellum.

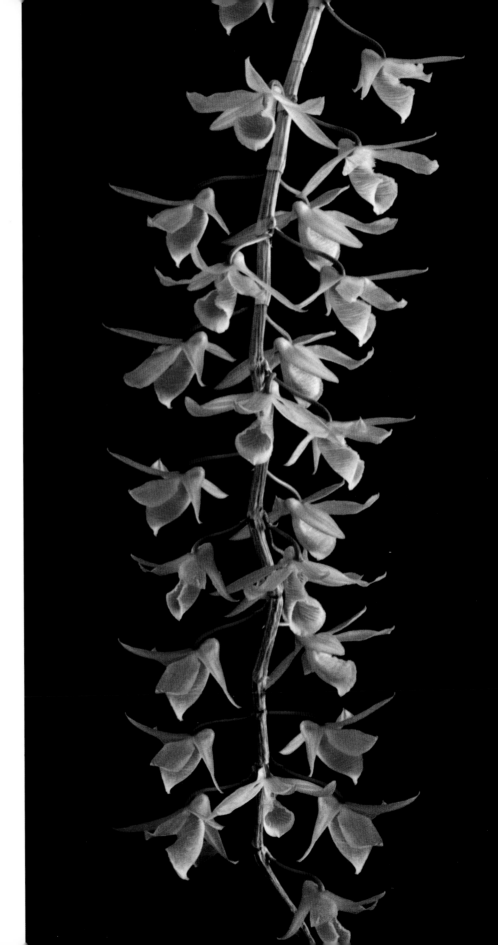

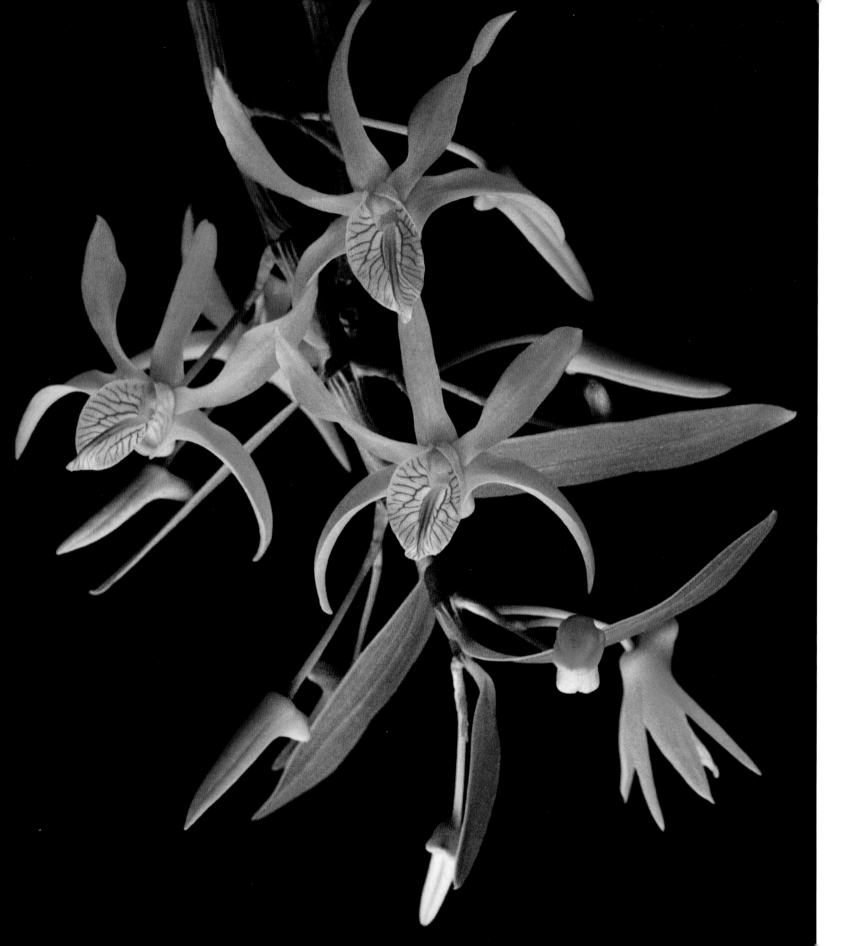

A collector's item like no other, dream-catcher *Dendrobium unicum* is native to North Thailand, Laos, and Vietnam. It has been used to impart yellow and orange colors into hybrids.

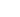

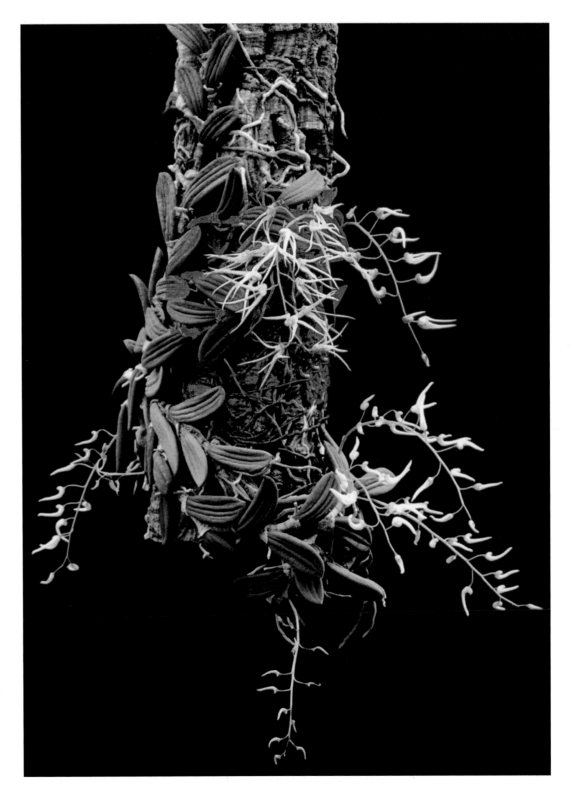

Dockrillia linguiforme, as it was called then, was introduced to England in 1810 by the legendary Admiral William Bligh — the same taskmaster immortalized as captain of the H.M.S. *Bounty*. Recently it has been reclassified as *Dendrobium linguiforme.*

Its leathery, ribbed, almost succulent leaves are probably an adaptation that helps it thrive in the full sunlight of its native New South Wales and Queensland. It is always mounted on its growing medium, to accommodate its demand for good drainage and its creeping, lithophytic (rock-growing) nature.

45

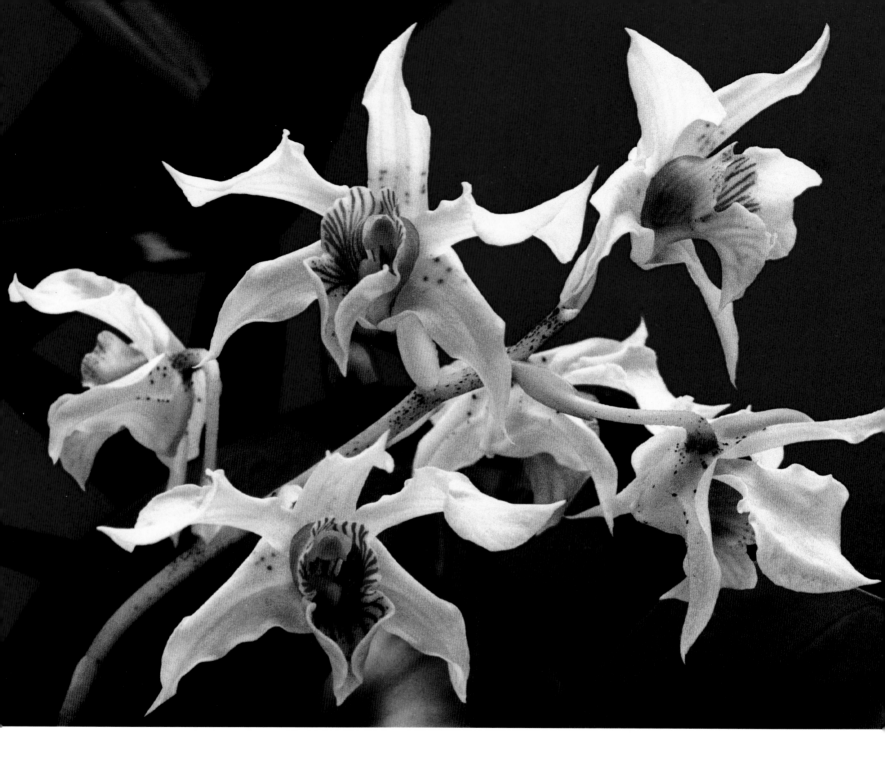

Another species from the Southern
Hemisphere, long-lasting
Dendrobium ultraviolaceum
is a compact grower with thick, substantial petals.

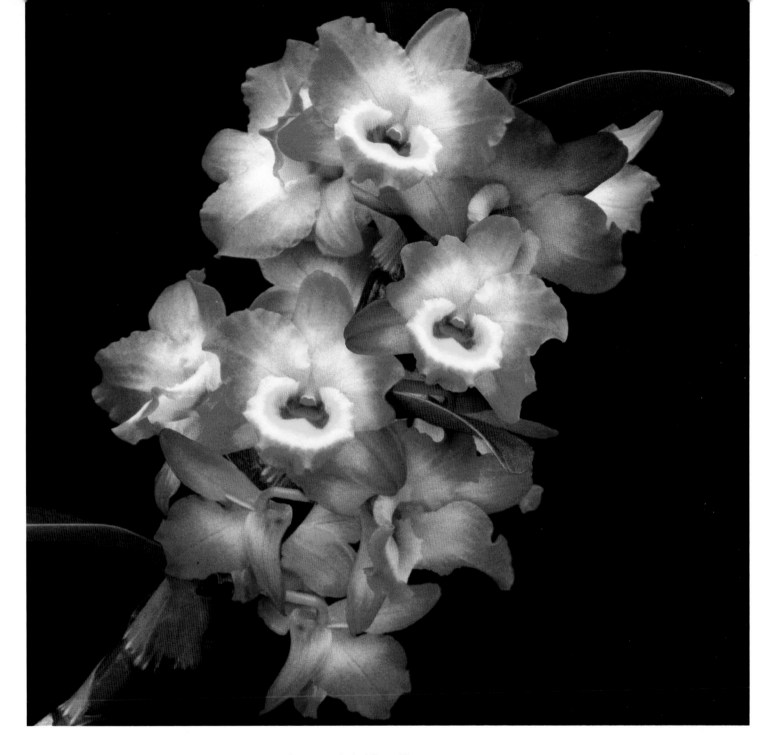

Japanese hybridizer Yamamoto
is world famous for perfecting
extraordinary color variations
in *Dendrobium nobile* hybrids. This is
'Akatuki'.

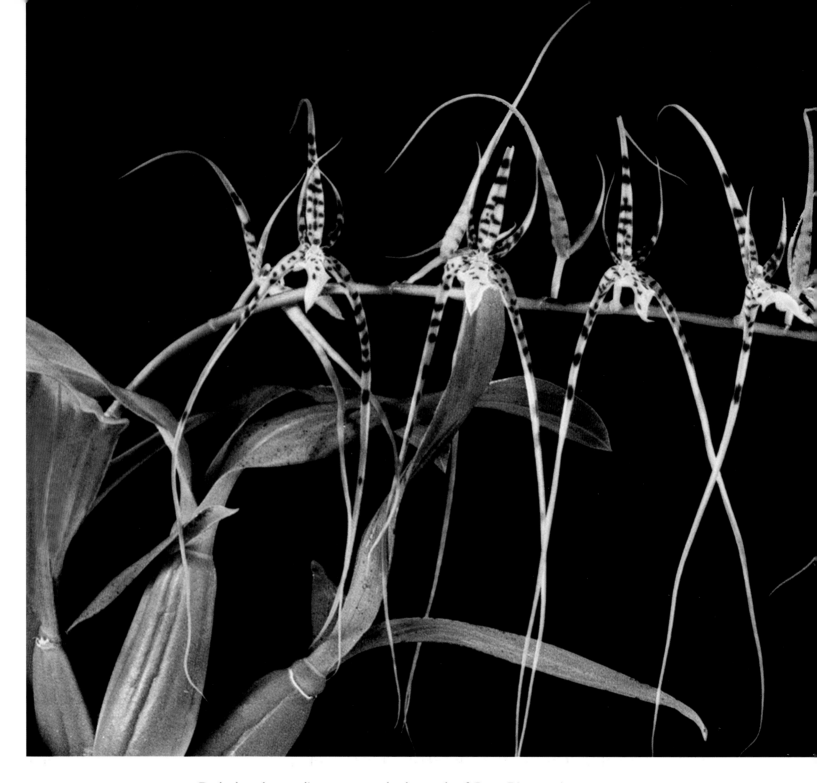

Dark chocolate on lime green marks the petals of Costa Rican native
Brassia longissima,
and its horizontal stem strikes a contrast with the extremely vertical lines of the flower.
The overall effect is as much restorative as stimulating.

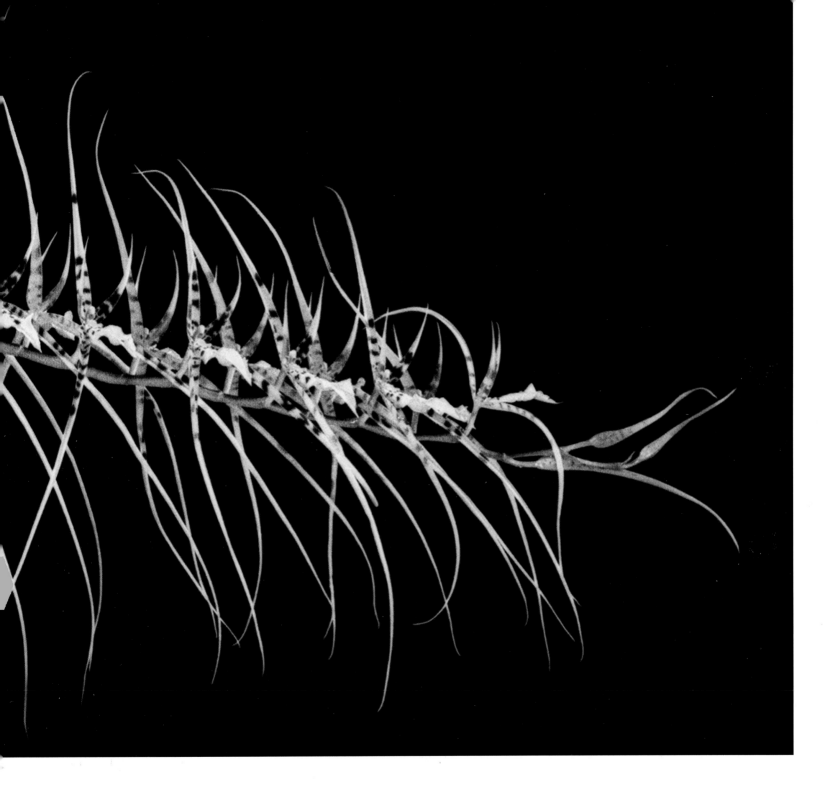

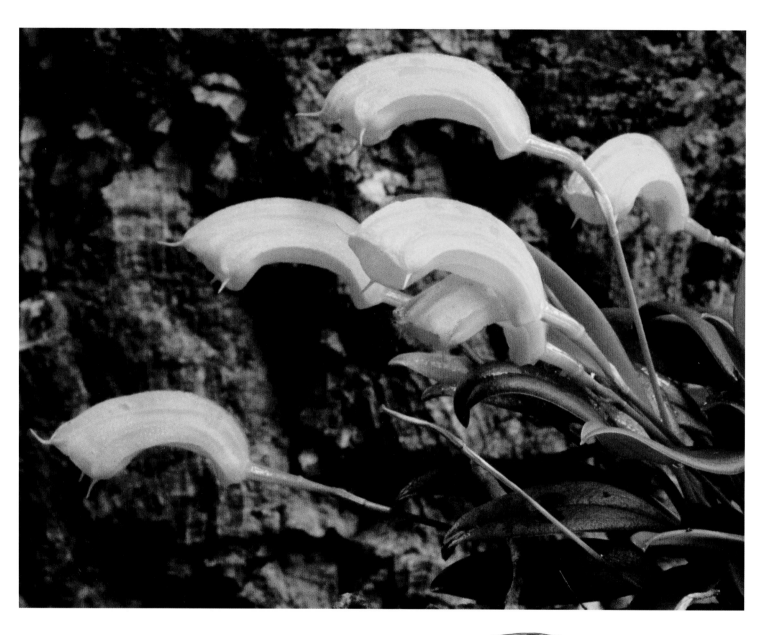

Masdevallia mendozae
looks like giant orange macaroni — or a large sea slug,
depending on your point of view. Like all
masdevallias, this curiosity prefers high humidity.

This graceful, rose-marbled spray of
Derosara 'Divine Victor'
is a new genus, created by Peter
Cataldo, a New England amateur
hybridizer, and named in honor
of a fellow hybridizer he
obviously admires.

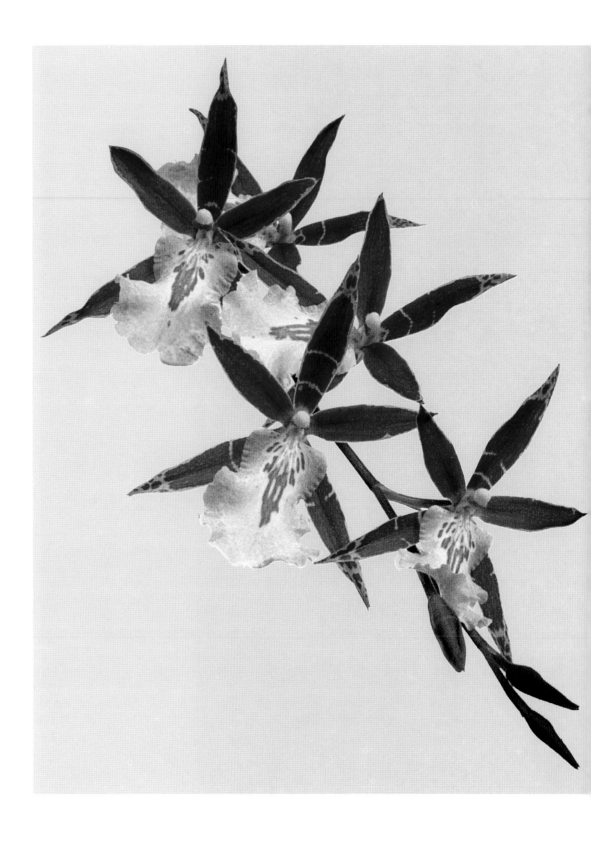

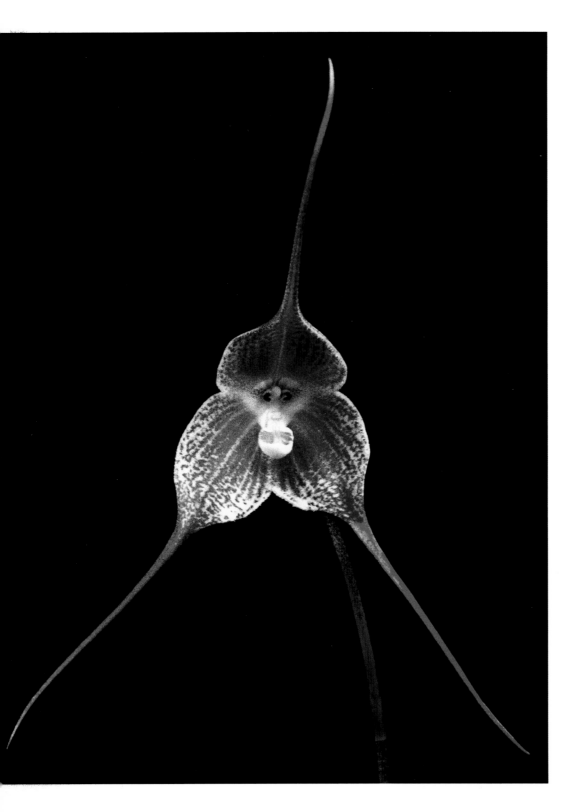

Whether you find it amusing or disturbing, it's nevertheless hard to ignore the monkey face in the center of this well-grown *Dracula,* one of a group of about one hundred species closely related to *Masdevallia.*

The dark rouge center of
*Masdevallia
veitchiana*
is attractive to a pollinating fly; the entire
flower is covered with a furze of tiny
purple hairs, giving it something of a
reverse weave color and texture. It was
named for Harry J. Veitch, the second of
British nurseryman James Veitch's two
sons. The surname appears frequently in
the botanical epithets of exotic garden
plants; in the nineteenth century this
horticultural dynasty sent collectors to
every part of the world in search of the
new, the beautiful, and the rare. This
prize is native to the high mountains
of Peru, where it grows terrestrially
among rocks.

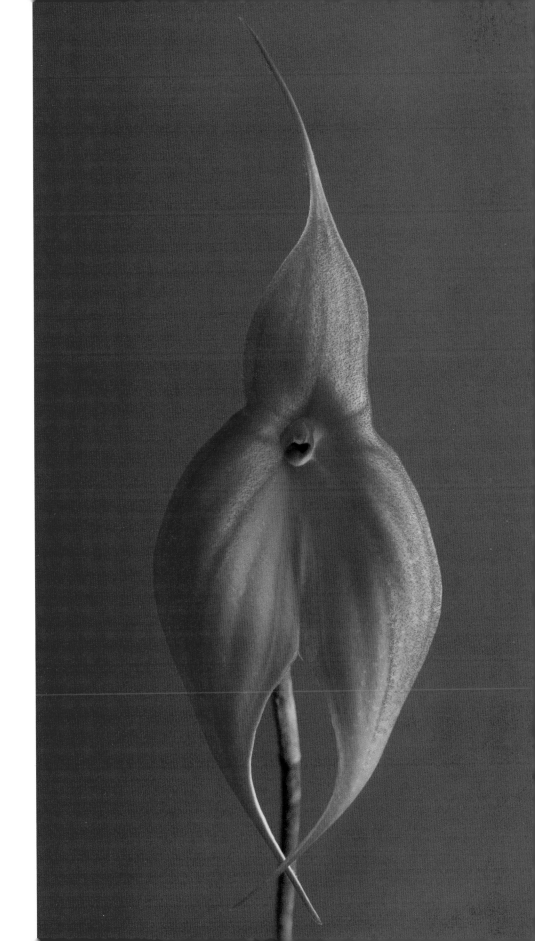

Pair of elegant
Phragmipedium caudatum
blooms. The long petals reach toward the
ground, creating a spiral stair as a help to
pollinators en route to the pouch. This
epiphytic or lithophytic species was origi-
nally described and placed in the genus
Cypripedium by English botanist John
Lindley in 1840.

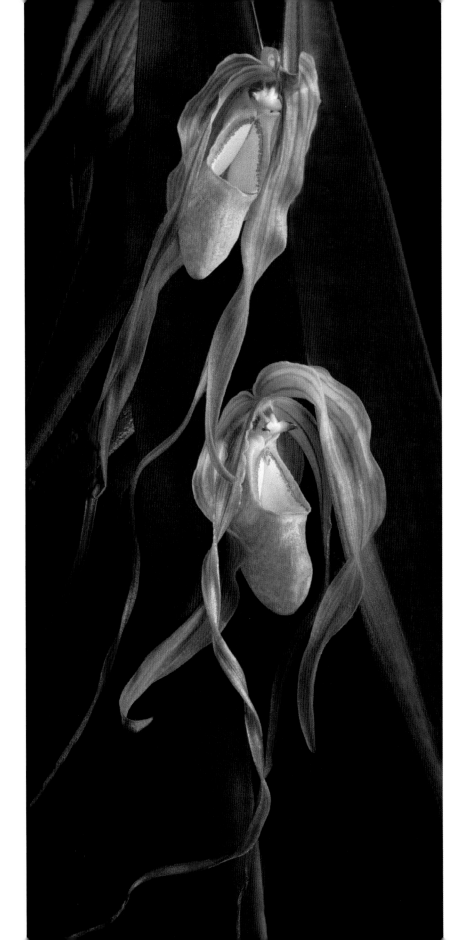

Slipper Orchids

The slipper orchids — of the genera *Cypripedium, Phragmipedium,* and *Paphiopedilum* — belong to a subfamily of their own, the Cypripedioideae. All share a showy, sometimes elaborately conspicuous pouch, a fusion of two petals. Unlike other orchids, they took a less traveled evolutionary path and retain a pair of primitive anthers. Many are terrestrial, or at least semiterrestrial. Without pseudobulbs or other means of water storage, slipper orchids need close attention to watering and humidity requirements in cultivation. They are among the most cherished of wildflowers and coveted of cultivated orchids.

The genus *Cypripedium* embraces cooler-growing terrestrial slipper orchids, which are distributed across the Northern Hemisphere, in North America, Europe, and Asia as far south as Taiwan. Though their image is familiar, these sentimental favorites are among the most difficult orchids to cultivate, less adaptable and tolerant of change than many tropicals.

Botanists distinguish *Phragmipedium* species — rarer still — from other slipper orchids by their infolded lip, typically elongated sepals, and a three-part ovary. They often have more than one bloom per stalk, with grassy bracts accompanying the flowers. An exclusively New World genus, phrags occur naturally in moist, tropical climates of Central and South America. Terrestrial, lithophytic, epiphytic, or semiterrestrial, they may grow in soil, on rocks, in trees — or in some intermediate niche. As with our native cypripediums, these plants can be difficult to cultivate, thriving in a narrow range of climatic conditions, where there is little room for a change of temperature, humidity, light, or growing medium.

Paphiopedilum orchids come from warm regions of India, Asia, and the Southeast Pacific. They are usually terrestrial, or somewhat epiphytic. Loving moisture and warmth, they have been cultivated in Europe and America for many years as indoor subjects for greenhouses, light tables, and even windowsills. They are available in a rich range of glossy colors, from chestnut brown to celery, and a satisfying variety of forms, and there are many splendid hybrids and varieties for beginners as well as connoisseurs.

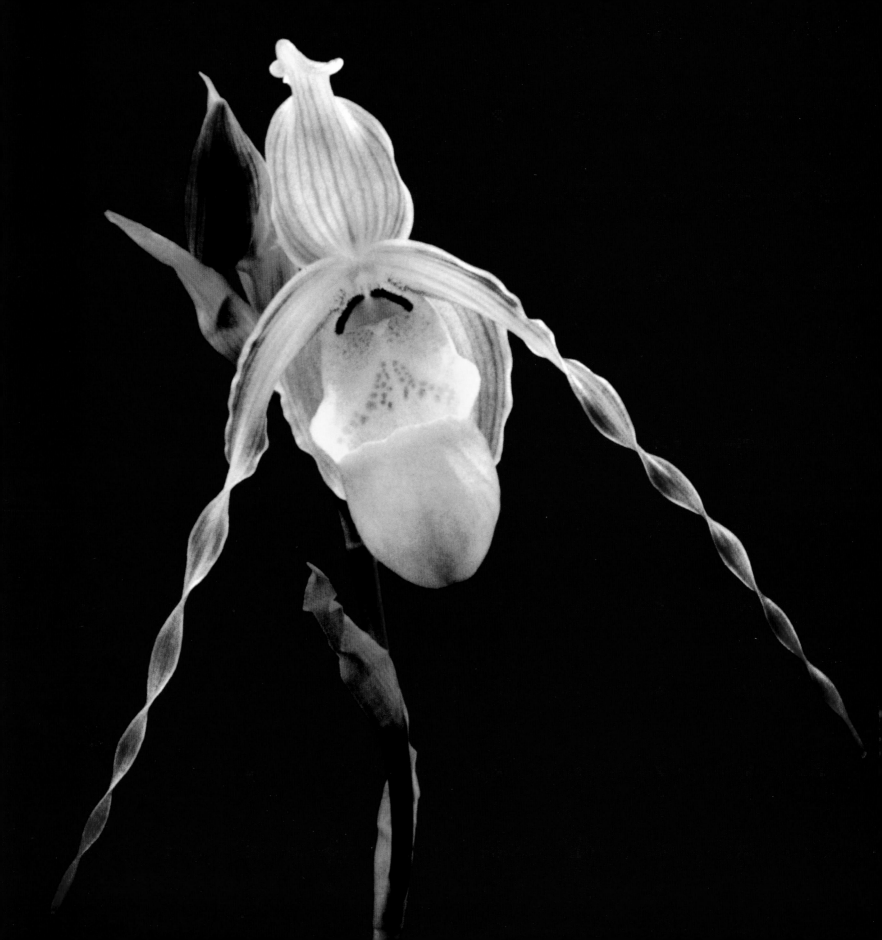

This sublime
Phragmipedium caricinum
is native to streamsides
and river rocks in
the Ecuadorean and
Bolivian Andes.

◀

▶

New to science
and horticulture,
Phragmipedium besseae
was discovered in 1981 by
Libby Besse of the Marie
Selby Botanical Gardens, on
exploration from Sarasota,
Florida. Native to the rocky,
moist slopes of the eastern
Andes, it has proved a
monumental if accidental
find, bringing intense scarlet
coloring to a new race
of cultivated phrags.

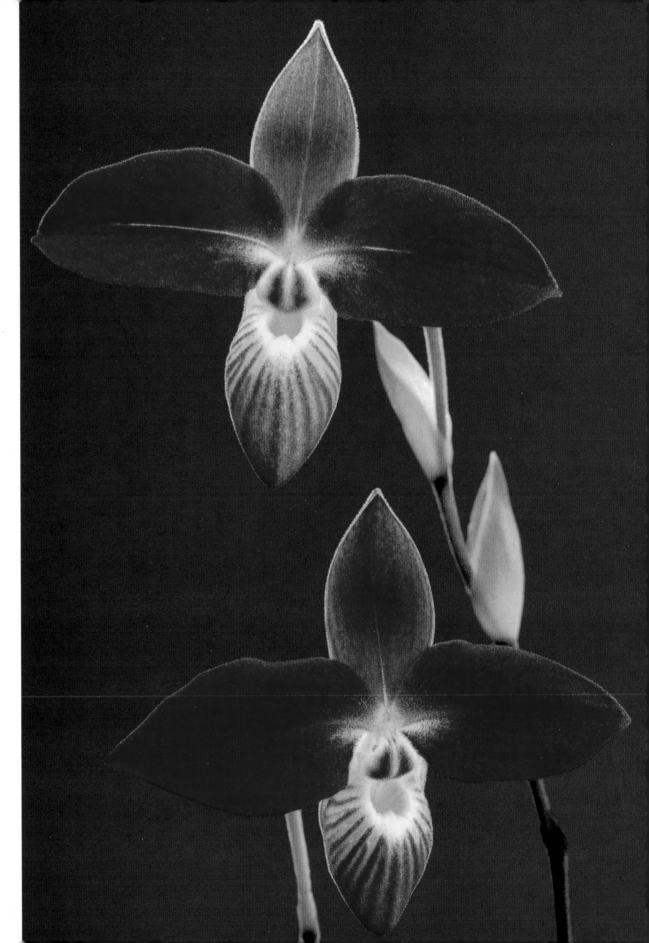

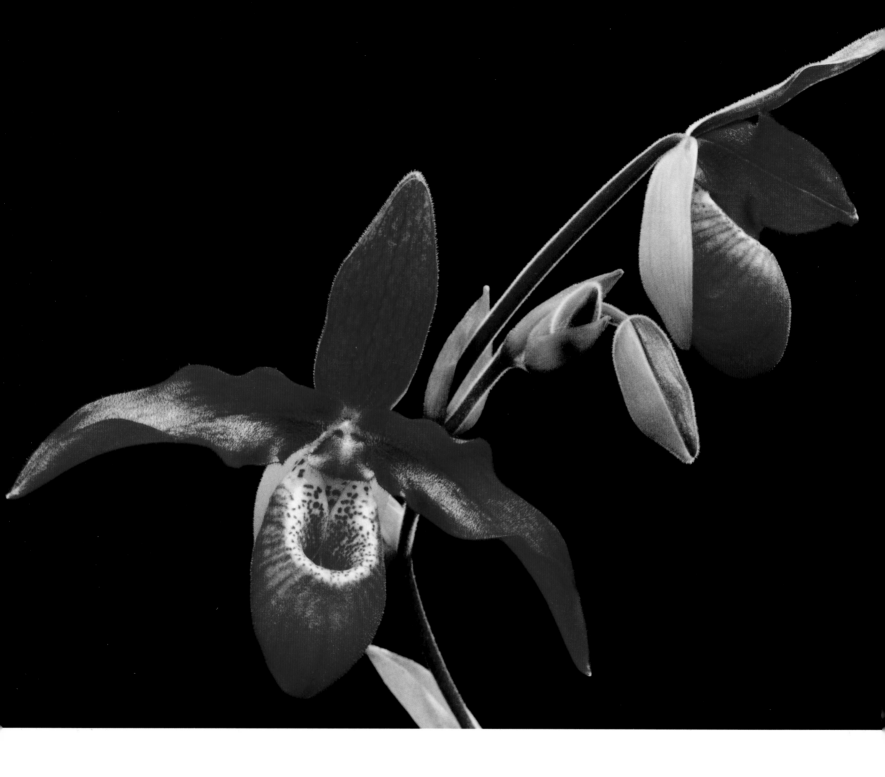

This incendiary second-generation
Phragmipedium besseae cross is
'Andean Fire'.

Serene
Phragmipedium wallisii
takes petals to extremes. Reference
books sometimes treat this plant as
a variety of *P. caudatum*.

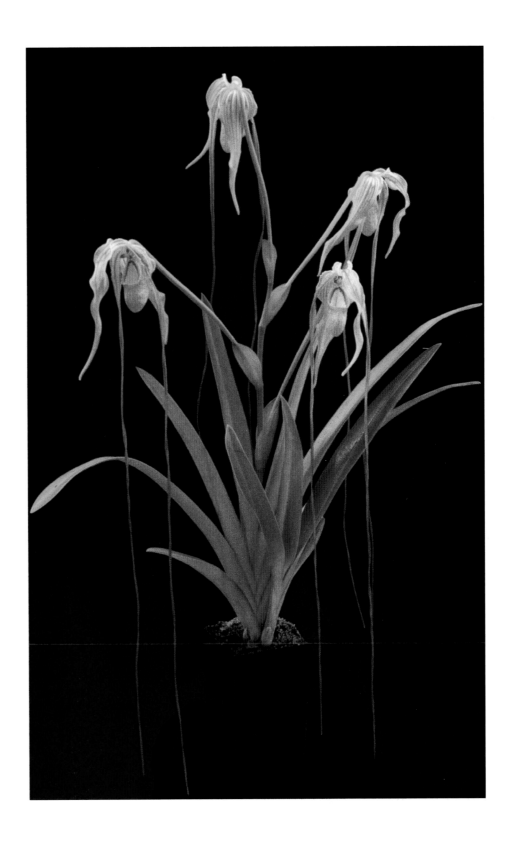

Long, longer, longest.
Phragmipedium
Grande 'Maybrook'
is a primary, or first-generation,
cross of *P. caudatum*
and *P. longifolium*.

◀

▶

So rare, flowers of
a variety of golden
Cypripedium
calceolus
look like tiny balloons.

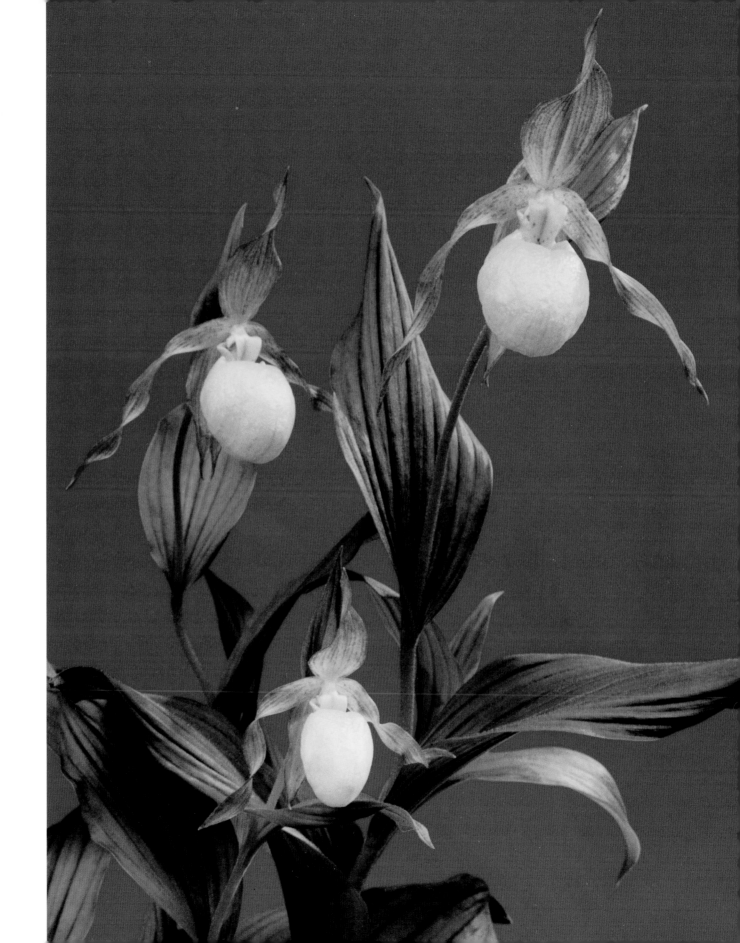

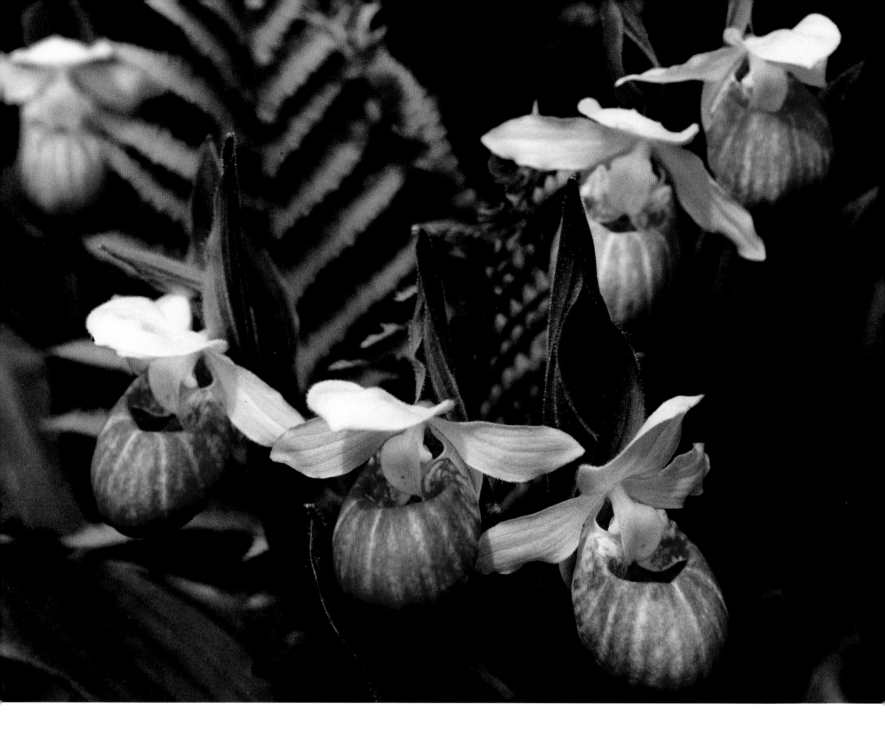

Increasingly rare,
Cypripedium reginae,
the showy lady's slipper, has white sepals and a painted lip. It is native to moist woodlands of much of the Northeast. This lovely colony was found in an alkaline bog in Vermont. Volunteer conservationists hand-pollinated these flowers and returned to collect seeds for modern in vitro culture; nursery-grown seedlings of this species show new promise as garden plants. Transplanting wildlings seldom succeeds — but always disturbs native populations.

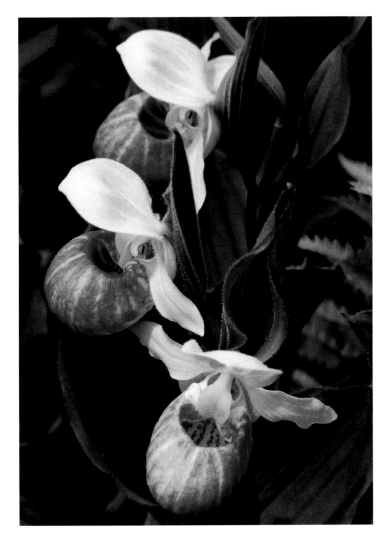

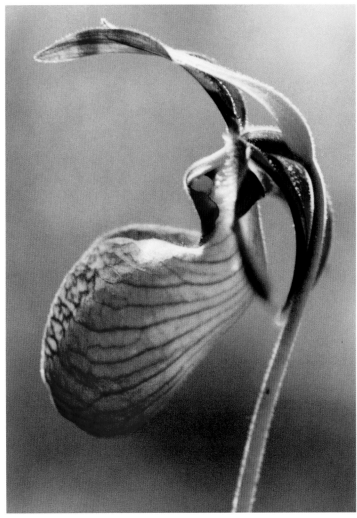

Queenly
Cypripedium reginae
is the most widely dispersed cypripedium,
with a range throughout Europe, temperate
Asia, and North America. Unfortunately,
their realm is greatly reduced. Their
conspicuous, slipperlike flowers have made
them all-too-easy prey for the
unscrupulous and the misinformed.

Sweet May sentinel of northeastern American woods of pine
and birch, this beloved flower has many names:
moccasin flower, lady's slipper,
Cypripedium acaule.
Bees detained for pollinating must escape through the aperture
at the top of the flower or chew their way out. This specimen
was photographed at Garden in the Woods, Framingham,
Massachusetts, headquarters for the New England Wild Flower
Society. The society's native cypripedium collection provides
plant material that is critical to conservation efforts.

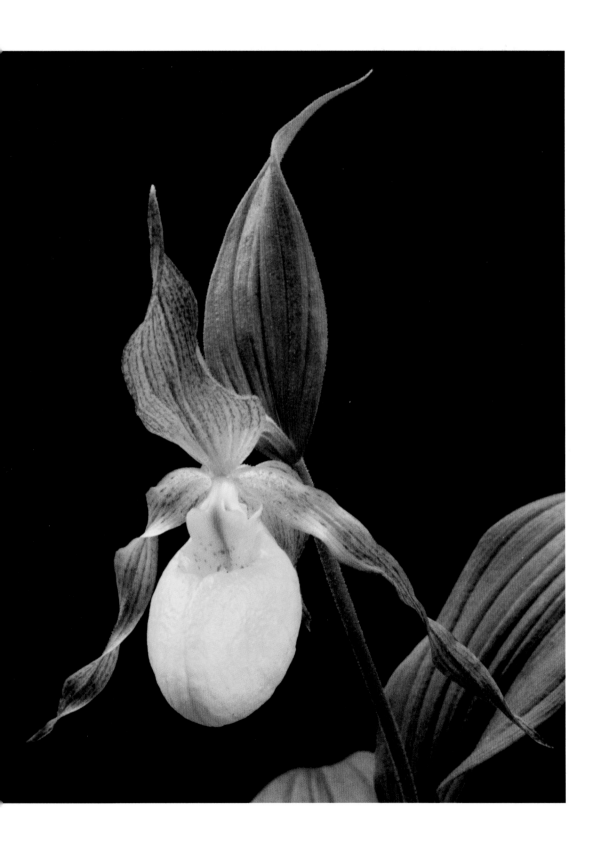

Collectors treasure golden yellow
Cypripedium calceolus
var. *pubescens.*
For many amateurs, the simplest
way to enjoy such delicacies is
to visit flower shows and botanical
gardens where orchids
are exhibited.

Pleated leaves distinguish
Cypripedium japonicum var.
formosianum
from kindred species. Once a common
wildflower in its native Taiwan, the species
is still considered the easiest cypripedium
to grow in the home greenhouse. The
cultivated variety pictured is award-
winning 'Trident Twinkletoes'. Boston
hobbyist Dr. Wilford B. Neptune meets
its cold requirements with a little help
from the vegetable crisper in his fridge.
He has succeeded in growing about ten
such temperate-climate cypripediums as
potted plants. He starts them in spring in
a special woodlands compost, keeps them
moist with rainwater, and feeds with fish
meal and seaweed every week until early
August. To simulate winter, he unpots
them and cuts off their leaves after the
first hard frost of fall, carefully wraps the
root and crown in plastic, then puts them
into the refrigerator. They need vernal-
ization — at least three months of 35–40
degree temperatures — to produce leaves
and renew growth the following spring.

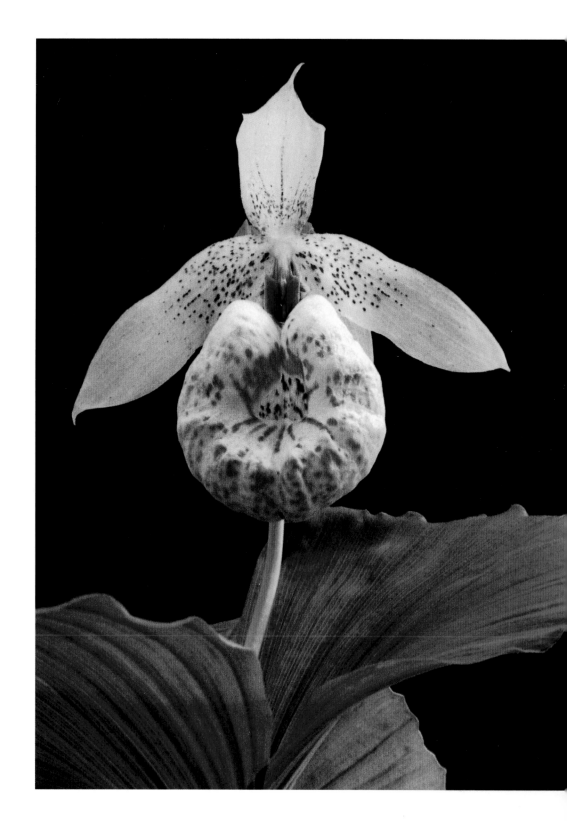

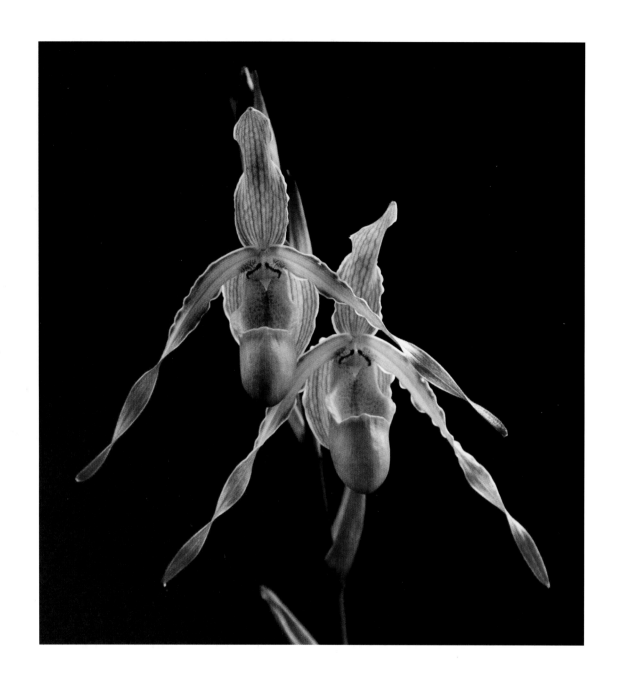

Trick or treat?
Phragmipedium Sorcerer's Apprentice 'Mickey Mouse'
blooms and blooms, as endless as the parade of bucket-carrying
brooms in the classic animated Disney film.

Fragrant, delicately colored *Paphiopedilum micranthum* is endangered in its homeland. Like many species native to Vietnam, it needs an alkaline, lime-based growing medium, and rainwater or reverse-osmosis filtered water.

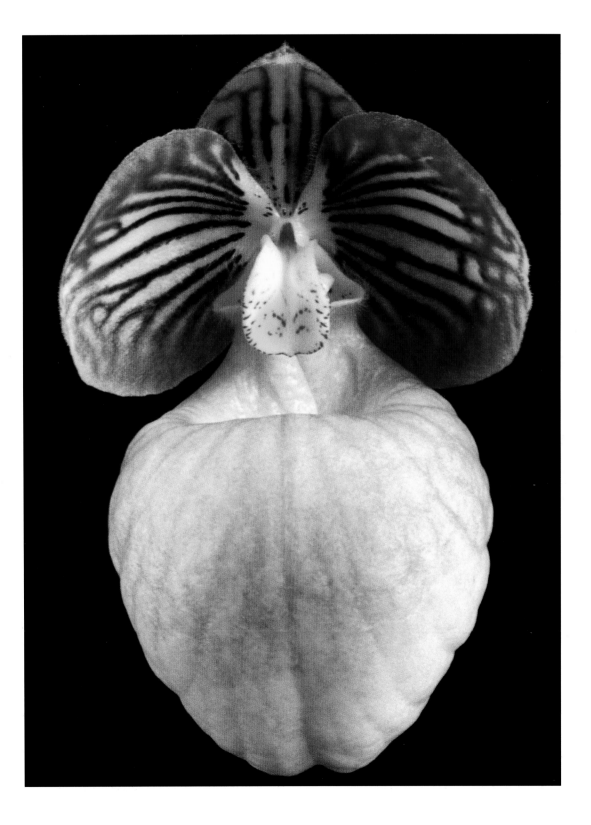

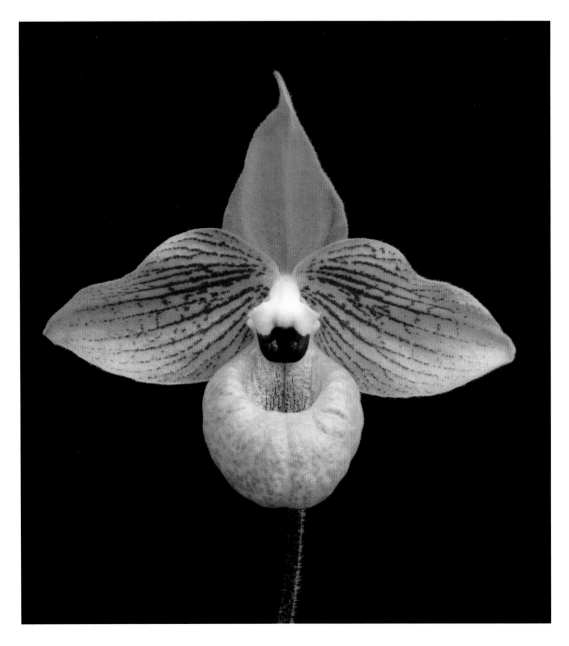

The chartreuse flowers of ***Paphiopedilum malipoense*** smell like raspberries and grow on very tall, 24-inch stems. It blooms in spring in its native southwestern China, where many wild orchids are threatened, and all species of *Paphiopedilum* are protected by law. Pollen exchanges and nursery-grown plants have replaced old trade routes and free-wheeling plant-collecting expeditions to China.

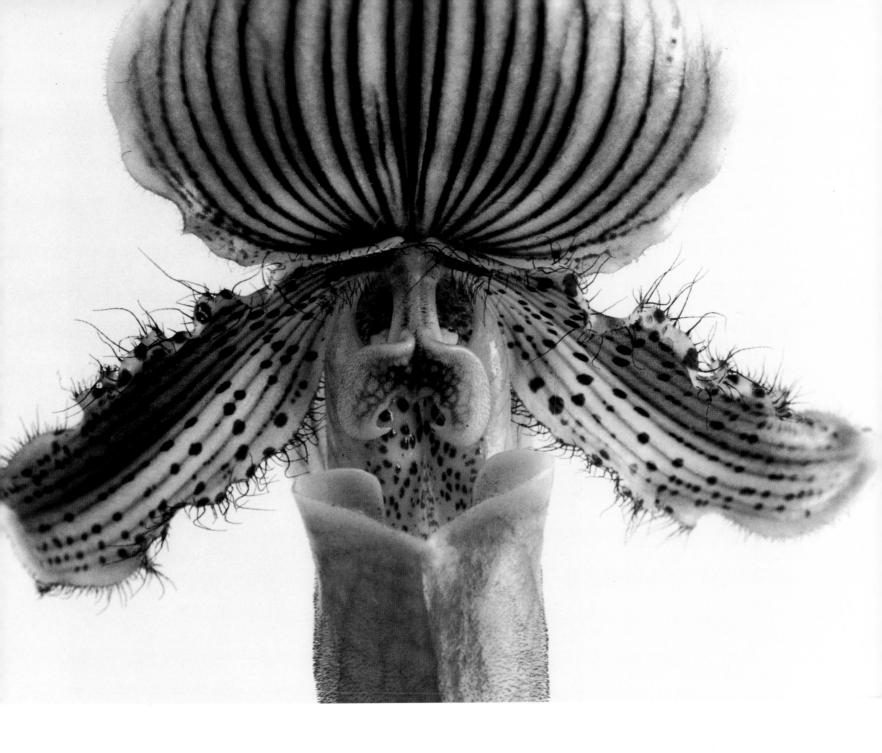

What big eyes you have. Tropical
Paphiopedilum argus
was aptly named for the many-eyed monster of Greek myth.
Like many warmth-loving slipper orchids, this Philippine species has lovely mottled leaves.

One of the famed "lost orchids" of the last century, *Paphiopedilum fairrieanum* flowered successfully in cultivation as early as 1847, but its origins were unknown until it was rediscovered in Bhutan at the turn of the century. With its striking patterns and dominant pointed dorsal petal, it has influenced the breeding of many modern cultivars.

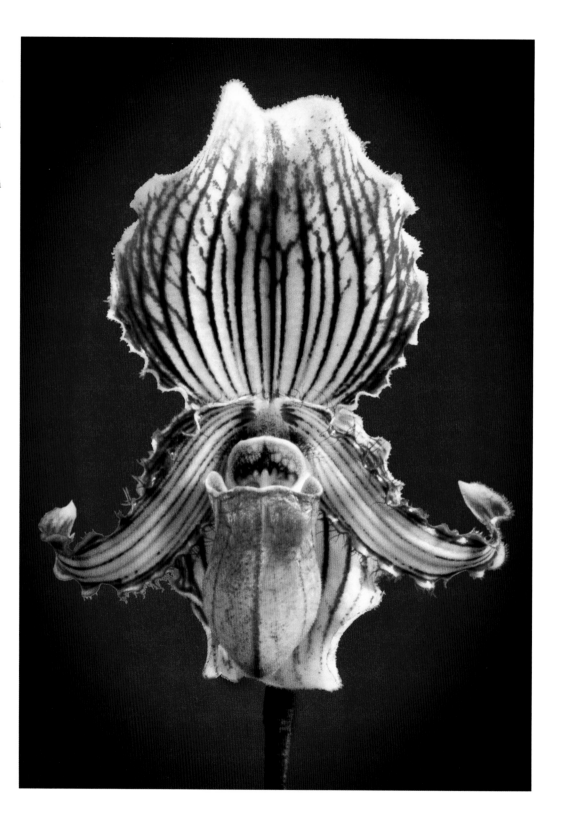

This trio of slipper orchids illustrates how closely related paphs and phrags are. This is *Paphiopedilum parishii,* unusual for its multiflowering habit. The aesthetic of the picture has a quiet, two-dimensional quality, an echo of an old botanical print.

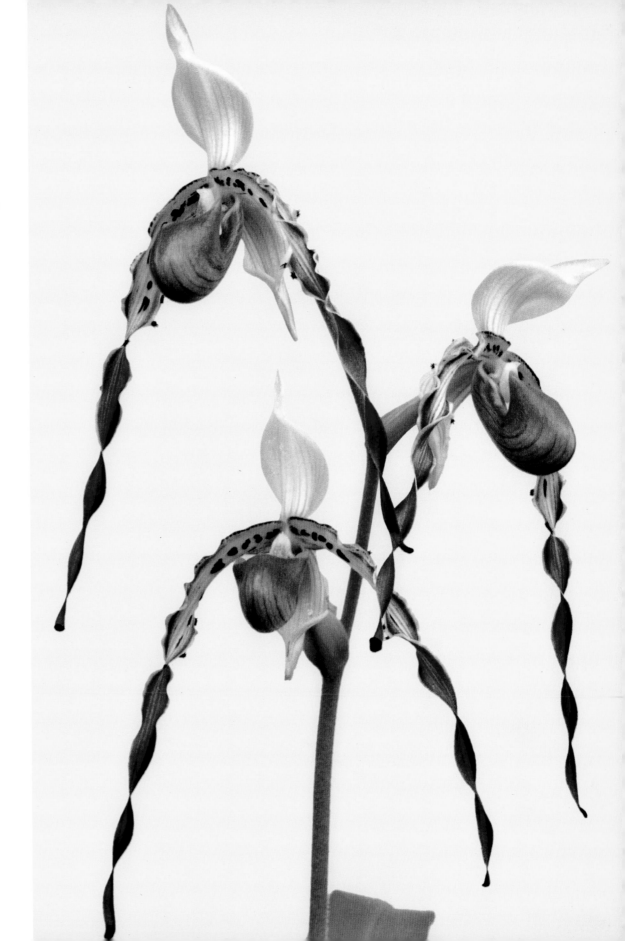

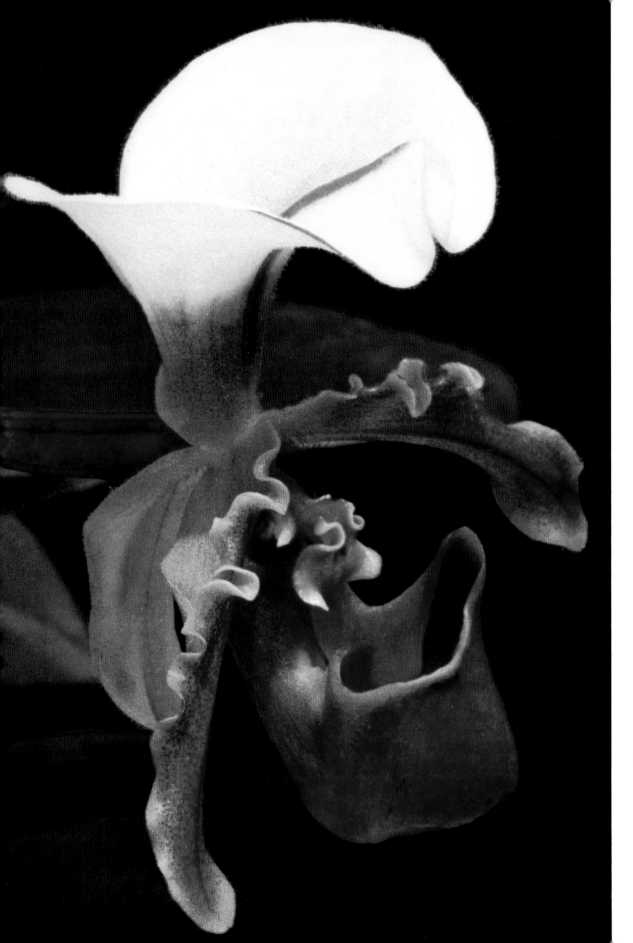

The turned-back hood and distinct vertical purple line of the back petal make ***Paphiopedilum spicerianum*** a keystone in many orchid collections. This tropical lady's slipper is found at elevations of 2,000 to 4,000 feet in northeastern India and Burma (Myanmar), where it lives high among cliffs where plants are constantly enveloped in mist.

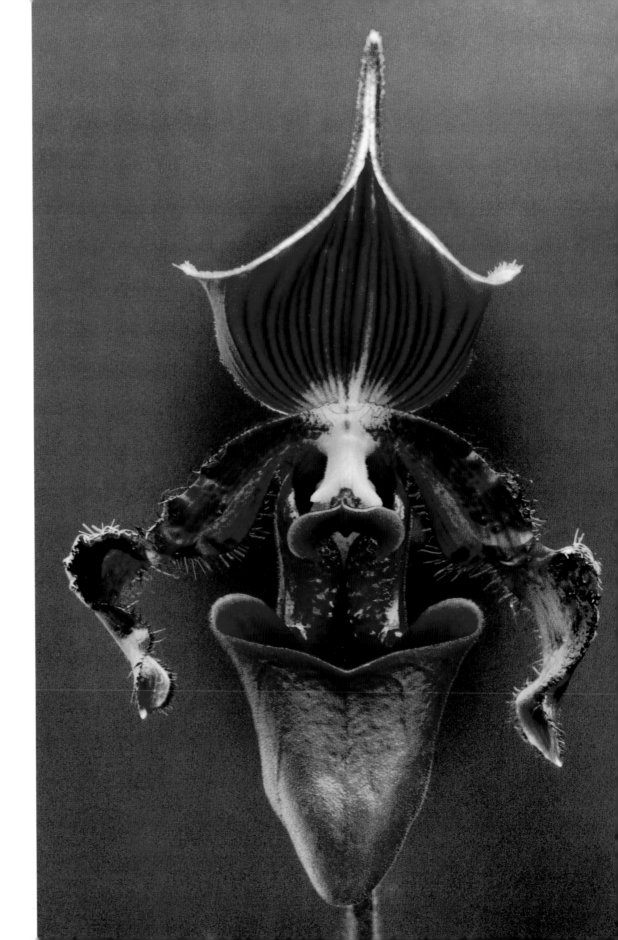

Mighty warlord,
Paphiopedilum
Holdenii × *P. argus,*
a burgundy study of fearless
masculine poise. This adaptable
shogun is a good choice for
neophytes and growers with
lower-light windowsills.

73

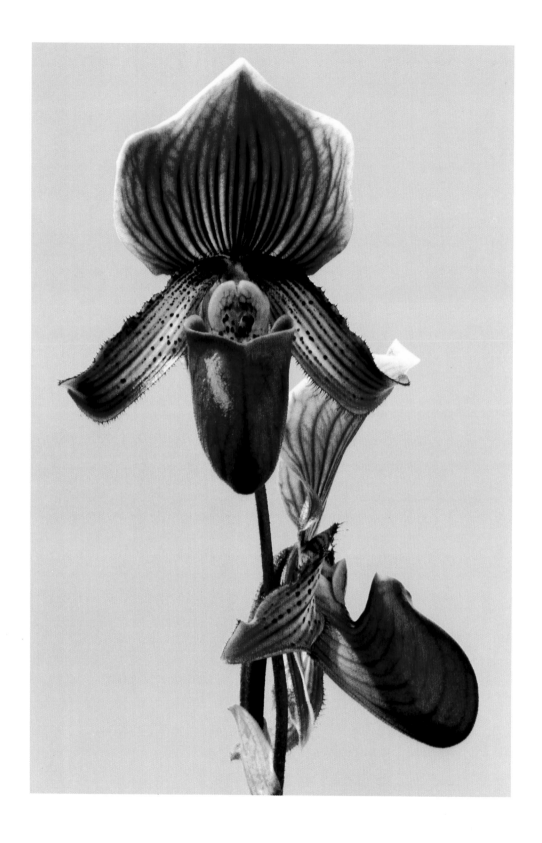

Dark stripes, wine-colored flesh, and pointed dorsal sepal are all hallmarks of this cultivated paph's lineage. To cognoscenti, this is obviously a descendant of *Paphiopedilum* Maudiae 'Coloratum'.

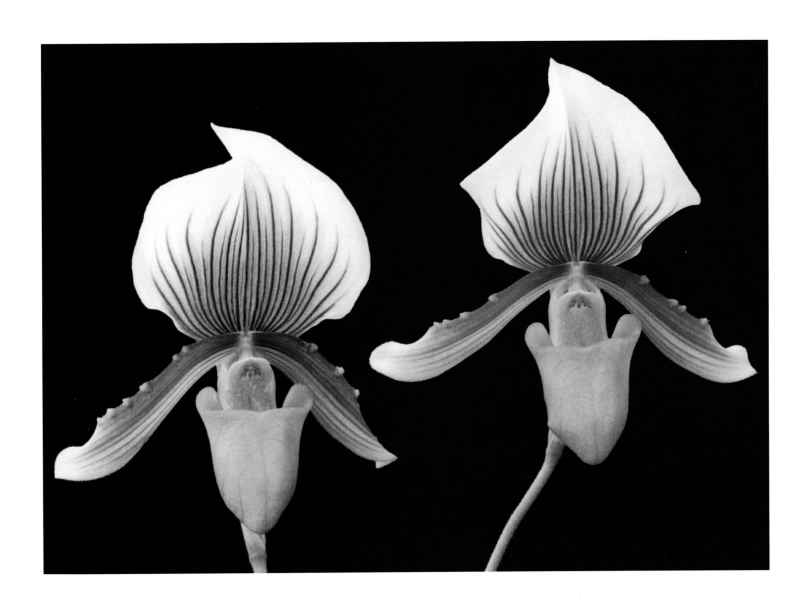

Its fraternal twin is crisp, celery-colored
Paphiopedilum Maudiae 'Alba',
from the same cross of *P. callosum* and *P. lawrenceanum.*
Visually refreshing among slipper orchids of
darker and earthier hues, this turn-of-the-century hybrid is
still a highly regarded mainstay among hobbyists.

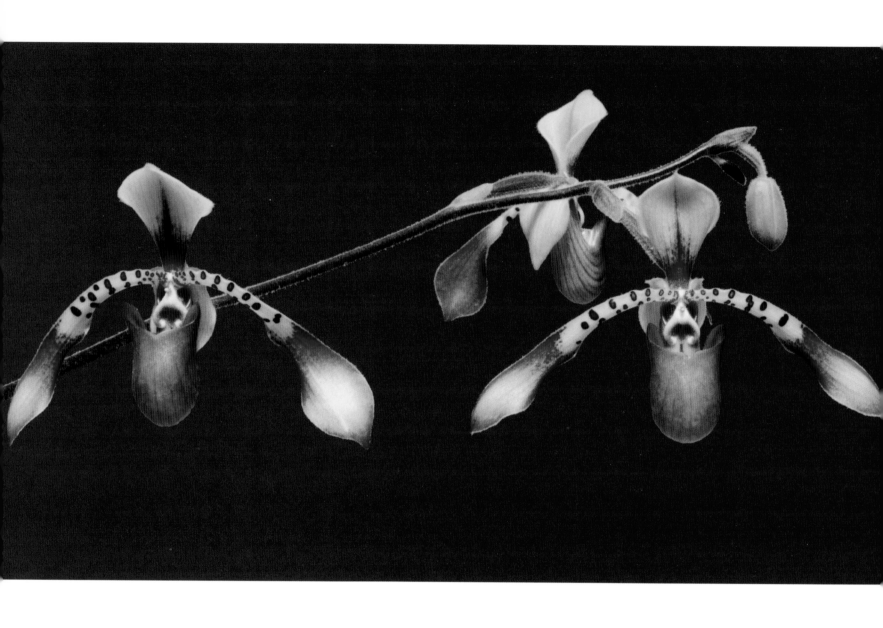

Illumination night. Vivid coloration and long,
horizontal inflorescence turn these blooms of Malaysian
Paphiopedilum lowii
into hanging Oriental lanterns.

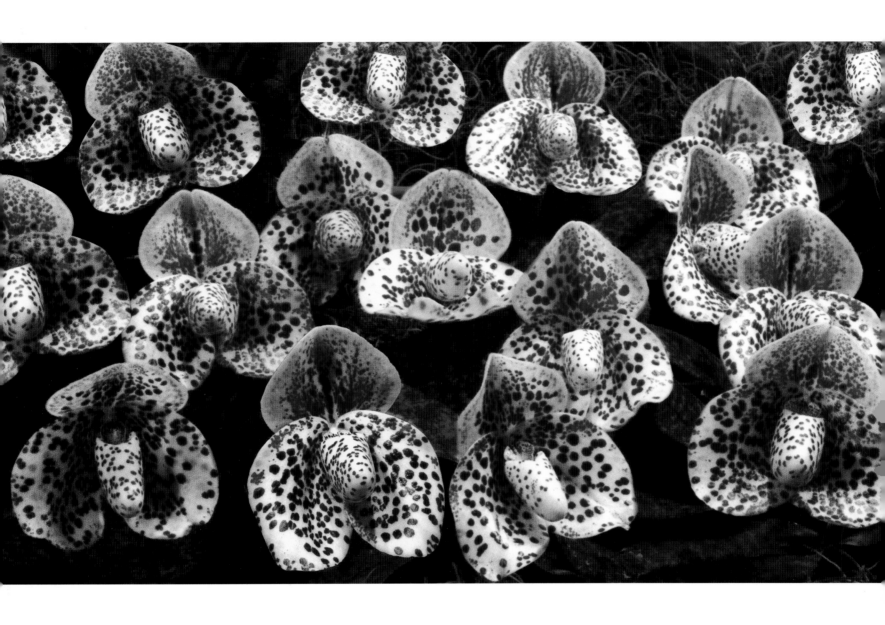

Playful specimens of
Paphiopedilum bellatulum
were created over many orchid generations, continually
selecting for vigor, uniform spotting, and other desirable traits.

Playing possum, Venezuelan native *Catasetum integerrimum* appears to be gone by before it is truly beyond its peak. Stranger still, it bears separate and different unisexual male and female flowers on the same plant; orchids are usually bisexual, with male and female organs integrated into one flower.

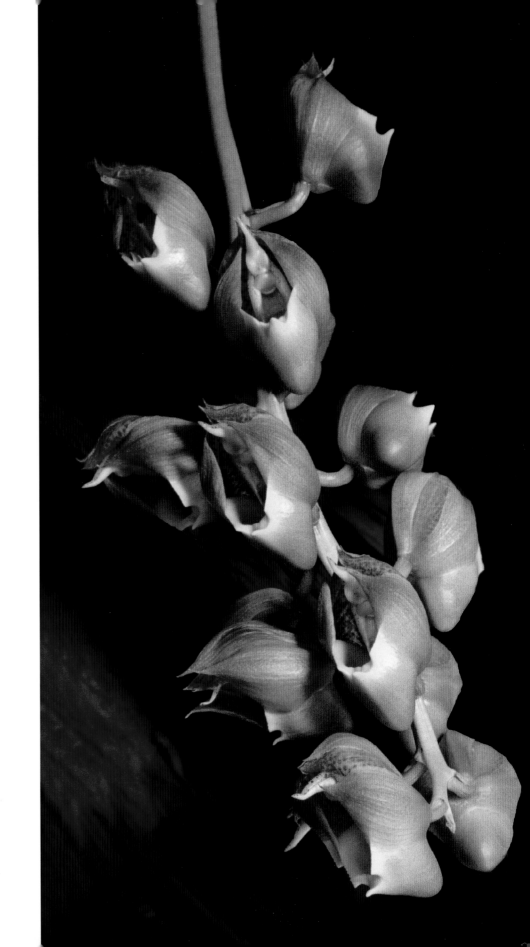

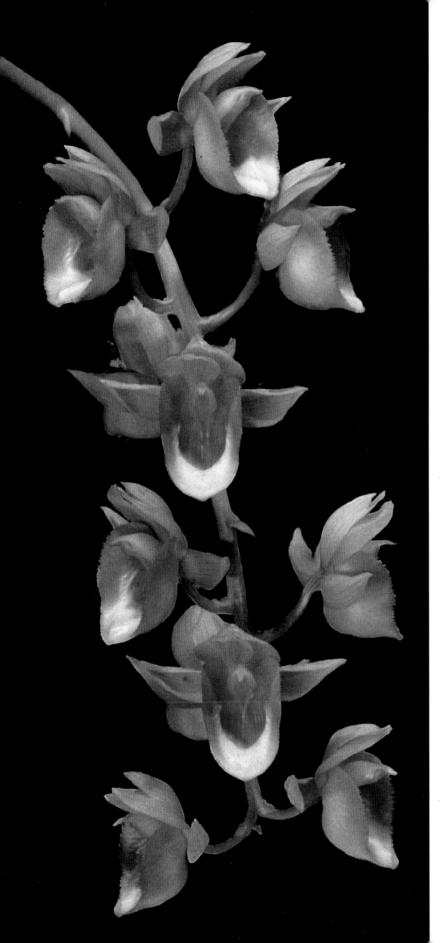

Male flowers of
catasetums
tend to be more numerous and showier in color, with
more pronounced arching displays. The male column
has a spring-loaded trigger mechanism that fires at
visiting insects to help ensure cross-pollination.

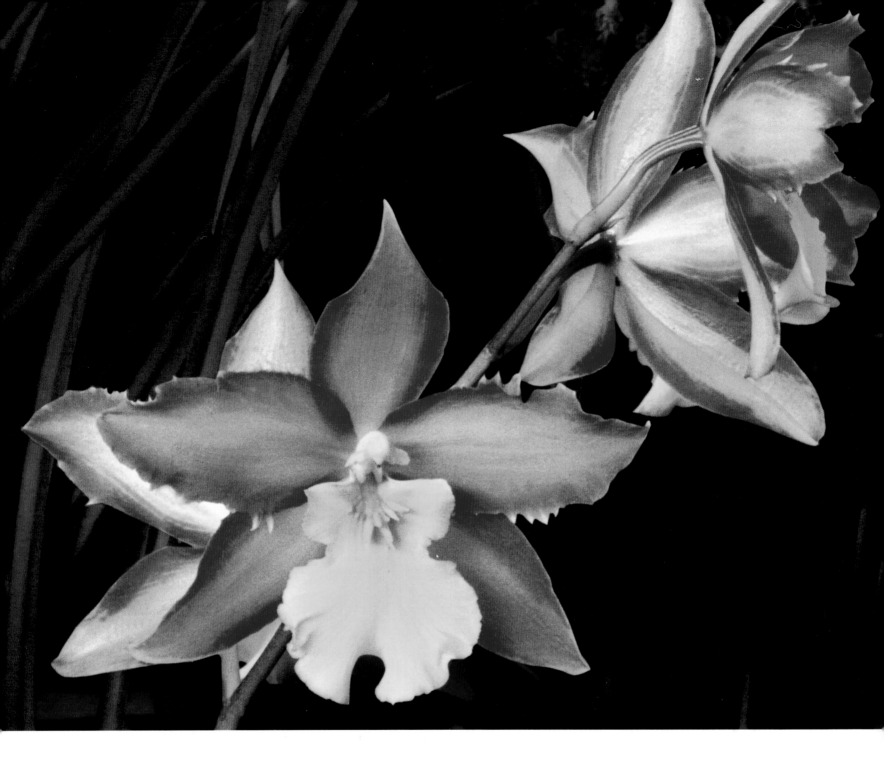

Tulip-bright colors characterize an *Odontioda* hybrid, the modern descendant of a historic
intergeneric cross made at the turn of the century from red *Cochlioda* and prolific *Odontoglossum*. This blossom,
Odontioda Wilsonara Ravissement Or D'Autumne,
has good cinnamon and gold color, without any pink or blue undertones.

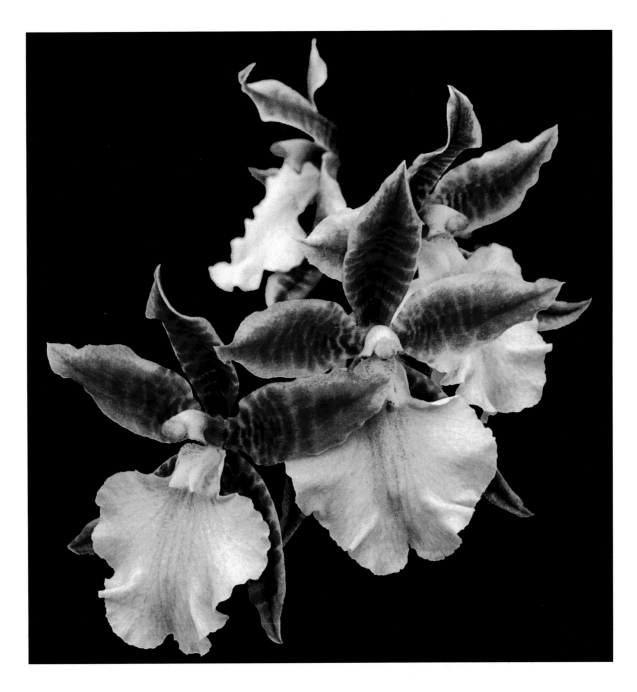

Though it belongs to a genus that loves cooler growing temperatures,
Lemboglossum bictoniense
(formerly *Odontoglossum bictoniense*) tolerates much more warmth than most; with it hybridists can breed plants (such as this one)
that are easier for amateurs to cultivate. Advanced growers maintain separate greenhouses for this tribe, with costly evaporative
coolers to create a cool, humid climate — no matter what the baking heat outside.

Snowy
Odontoglossum crispum
likes cooler temperatures. There are many
named forms of this variable, naturally refined species, which is
native to high-altitude cloud forests of Colombia.

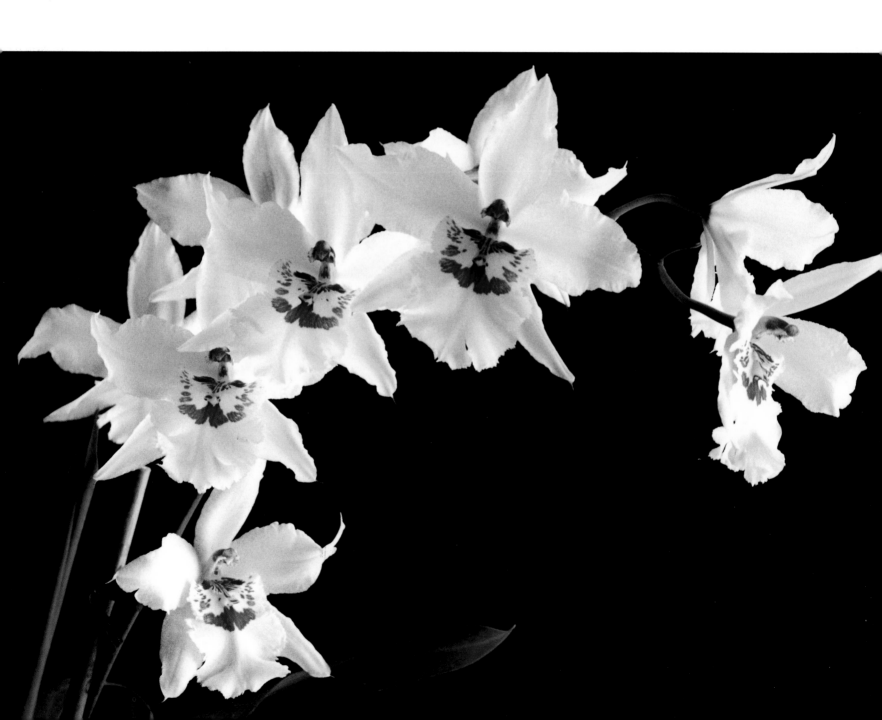

Hard to pronounce but easy to grow, this complex hybrid blooms several times a year. *Burrageara* Stefan Isler, a cross of *Vuylstekeara* Edna x *Oncidium leucochilum*, has at least four natural genera in its pedigree: *Cochlioda, Miltonia, Odontoglossum,* and *Oncidium.* Neophytes who struggle with orchid nomenclature should take heart in knowing that taxonomists don't always agree on what an orchid's name should be and continually revise them.

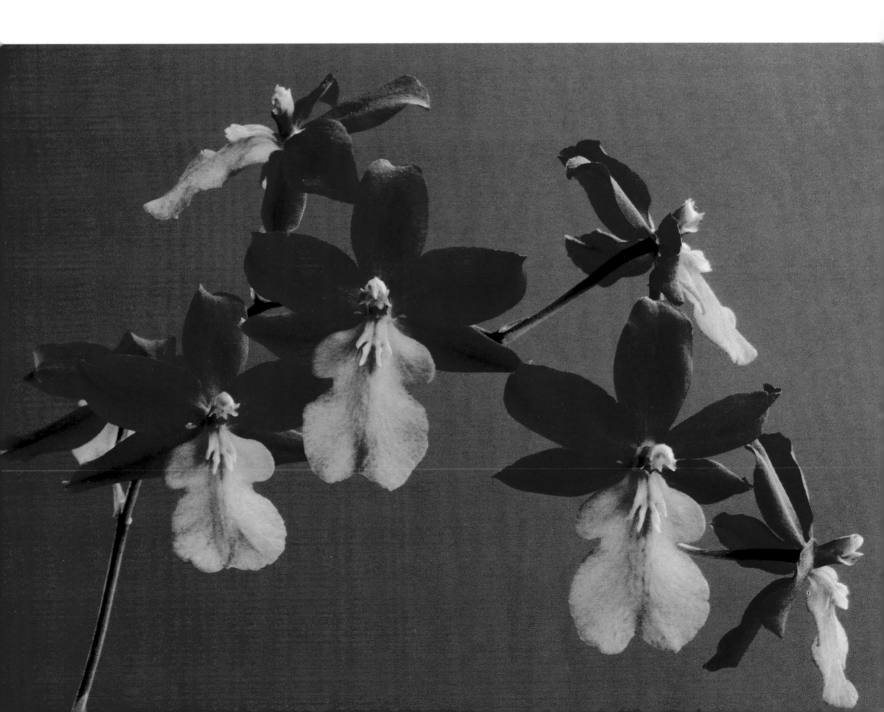

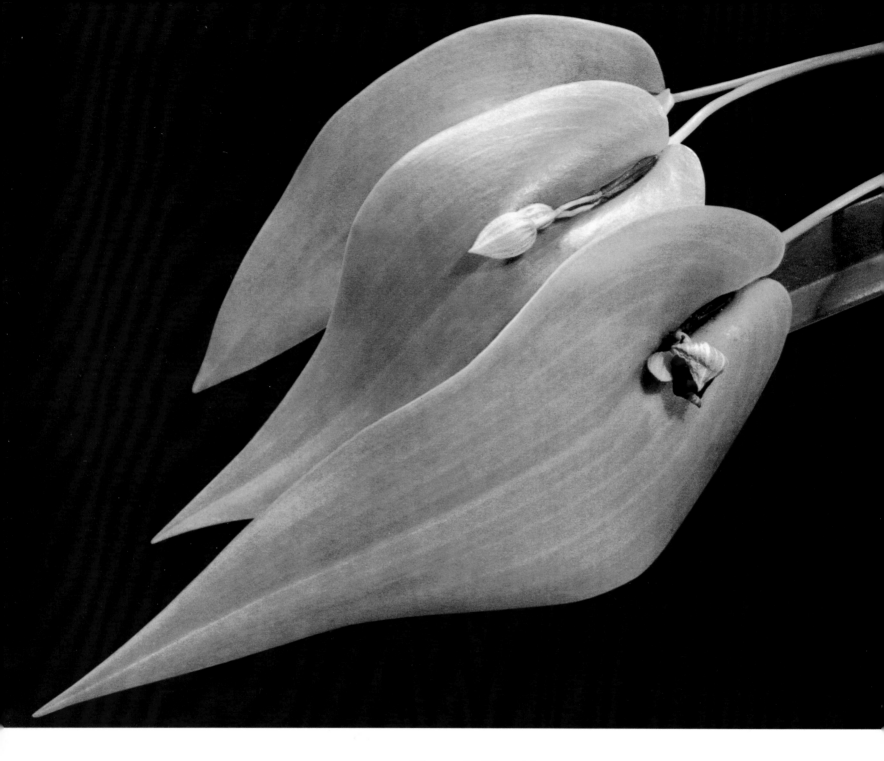

Tiny blooms of *Pleurothallis tridentata*
cradled in a leafy bract. Avid collectors admire miniatures like these with a hand lens. Native to tropical America, *Pleurothallis* is one of the largest genera in the entire family Orchidaceae. Botanists are beginning to devote more serious study to this fascinating group; sorting them out is a daunting task, owing to their shy blooms and sheer numbers. This species occurs from Venezuela to Peru. It is grown in intermediate to cool conditions for its pretty leaves and frequent blooms.

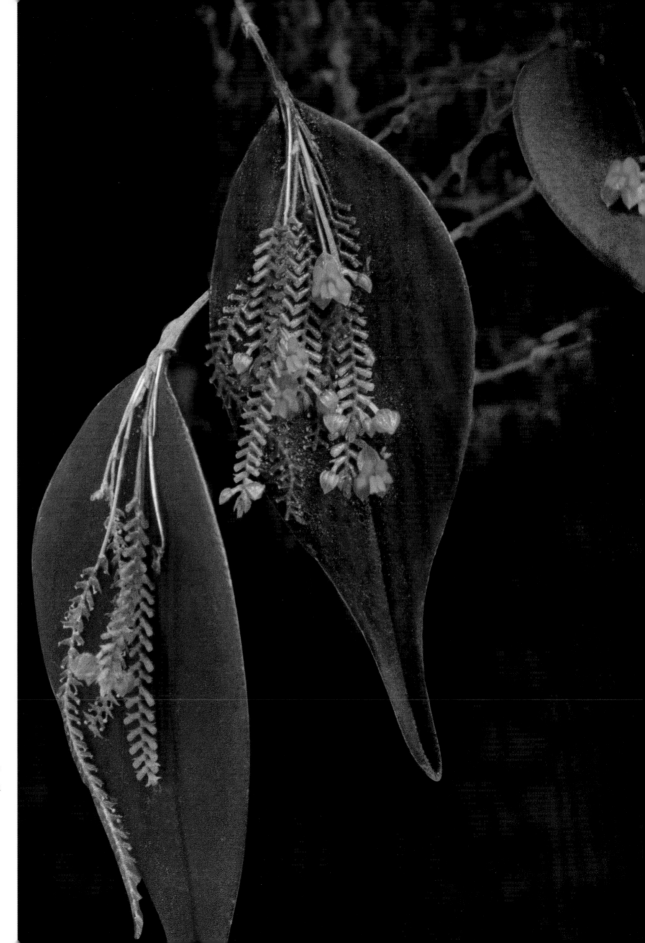

Here an entire
inflorescence of
Lepanthes
— blooms, buds, and
bracts — is reduced to a
minuscule spray. Closely
related to *Pleurothallis,* this is
another large South American
genus appreciated for its
enchanting growth habits
and tiny flowers.

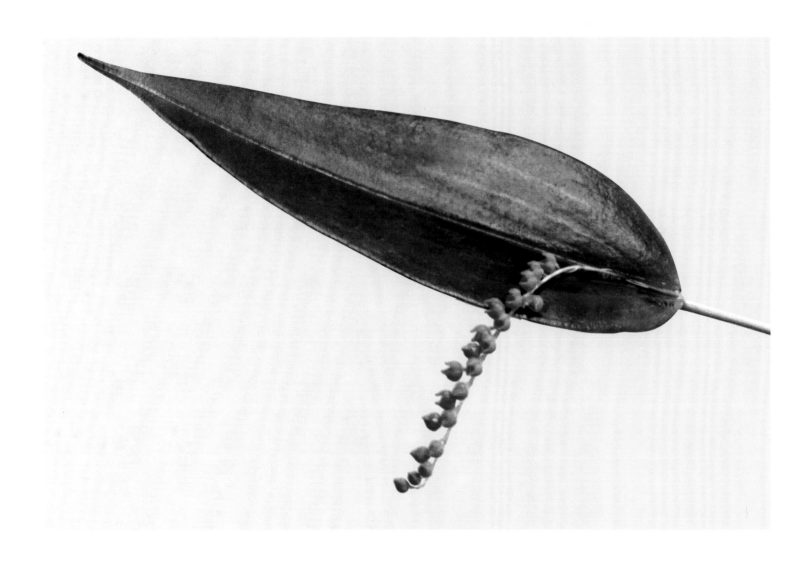

Pleurothallis truncata

Grass changes form,
becomes flower.
— Translation of the Japanese character for "flower"

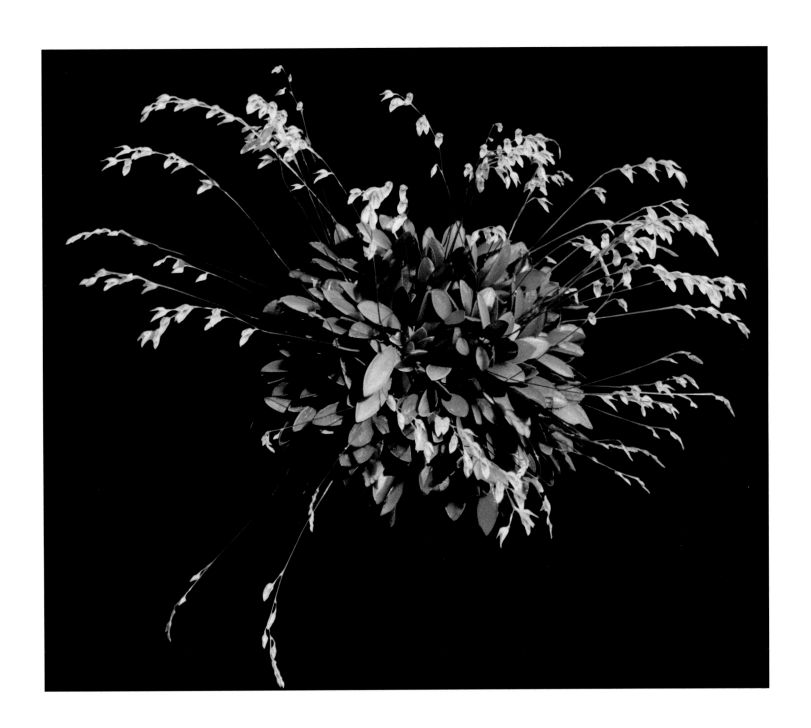

Pleurothallis grobyi

and its look-alike cousins have been cultivated since the
early days of British collecting. The entire plant grows only six inches tall.

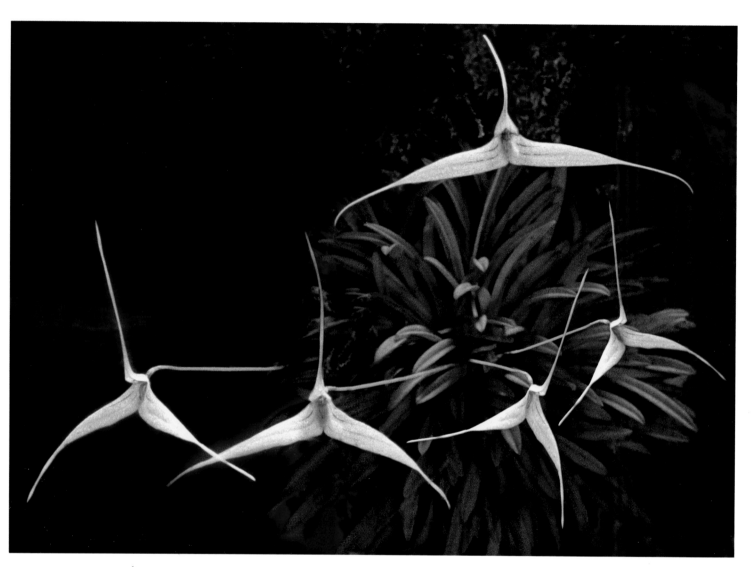

Blooms of white
Trisetella hoejeri
in flying formation resemble tiny origami birds.
The one-inch-tall foliage is dwarfed by two-inch-wide flowers.

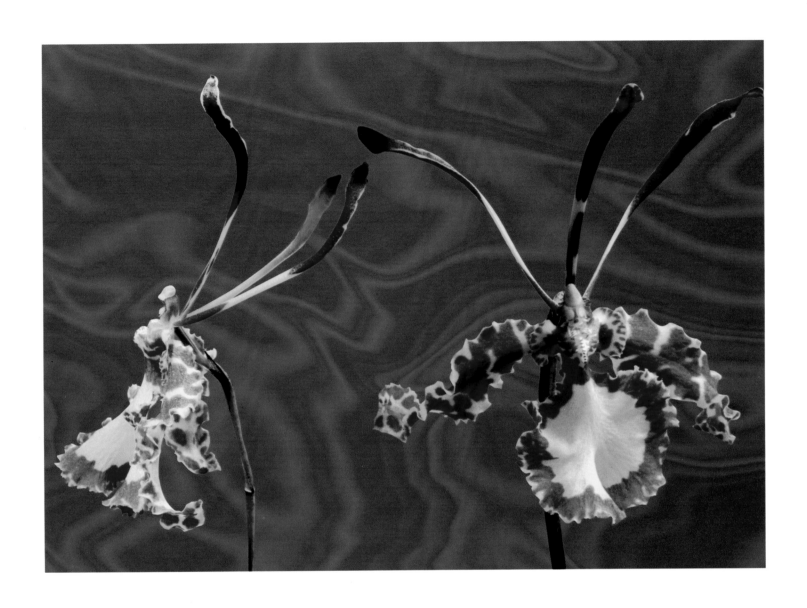

Psychopsis papilio
is a successive, exhaustive bloomer, producing one spectacular blossom
after another, and fully capable of literally flowering itself to death.
Formerly *Oncidium papilio*, it was one of the outrageous species that provoked
"orchidelirium," the orchid craze of nineteenth-century England.

This highly bred
Laeliocattleya Christopher Gubler
combines all the qualities desirable in a warm color.

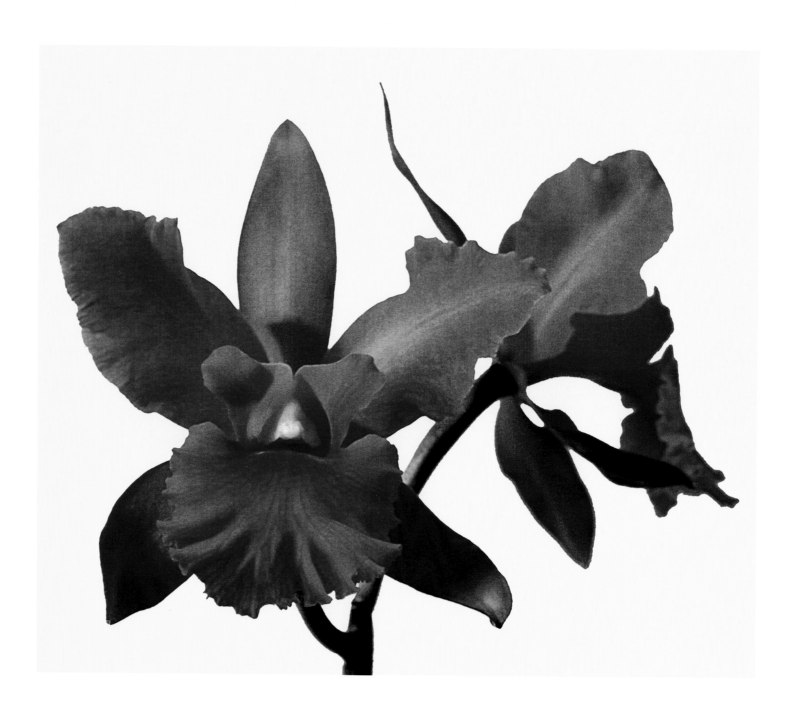

Perfect cameo.
Brassocattleya
'Fuchs Star'
is a hybrid of narrow-
petaled *Brassavola*
and *Cattleya*.
This intergeneric genus
varies widely in size
and form.

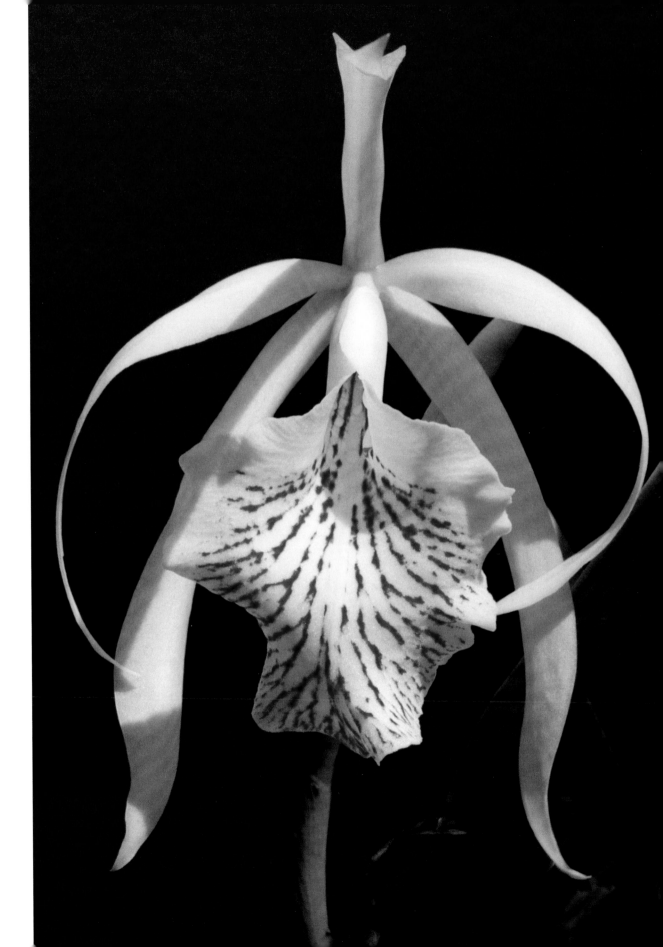

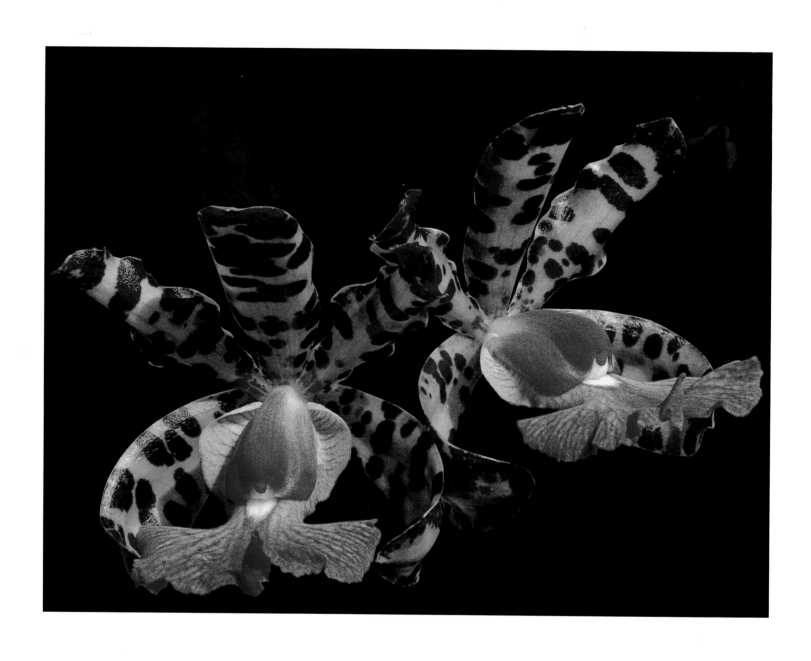

This is a very good clone of leopard-skinned Brazilian
Cattleya aclandiae,
discovered in 1839 and well used in many hybrids since.

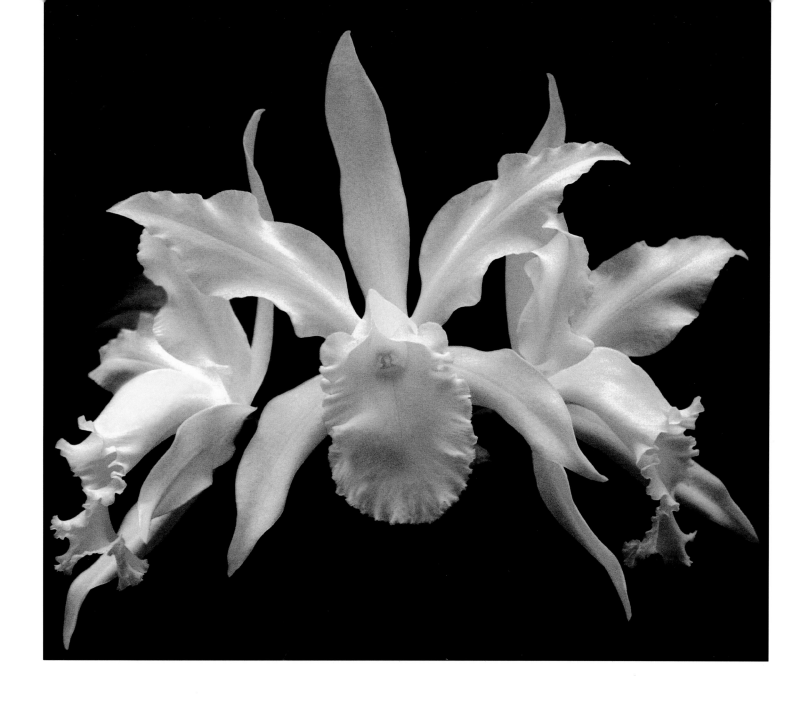

Always a bridesmaid, ivory-colored
Cattleya Louise Georgiana
is easily the most important cut flower of the florist's trade. A wholesale producer
may sell thousands of white blooms like this each year. Originally, cattleyas became popular as wedding flowers because
their fragrance has a remarkable resemblance to orange blossoms, which predate orchids in the traditional nuptial bouquet.

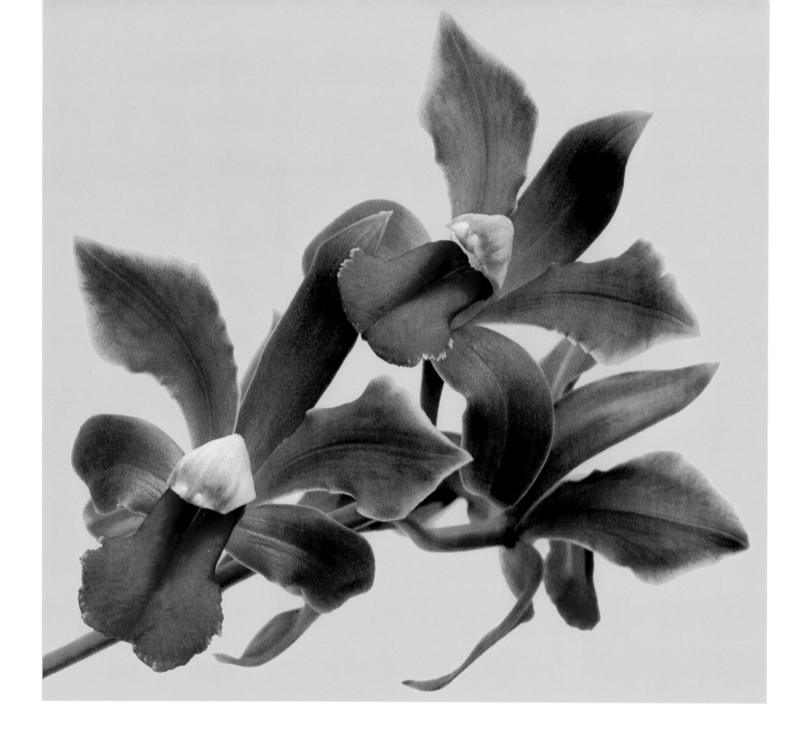

Botanical
Cattleya bicolor
is an important species for breeding. It is fragrant and has good substance,
unspotted sepals, prominent column, and, best of all, bright pink lipstick.

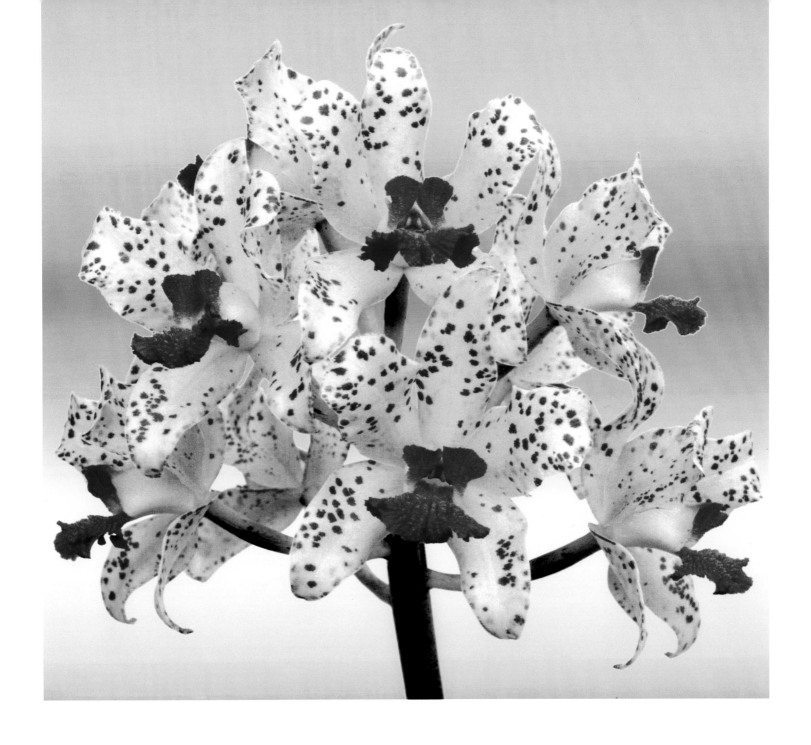

Pink-and-white
Cattleya amethystoglossa
blooms look like they were spatter-painted. Another Brazilian species,
it flowers in late winter in the Northern Hemisphere.

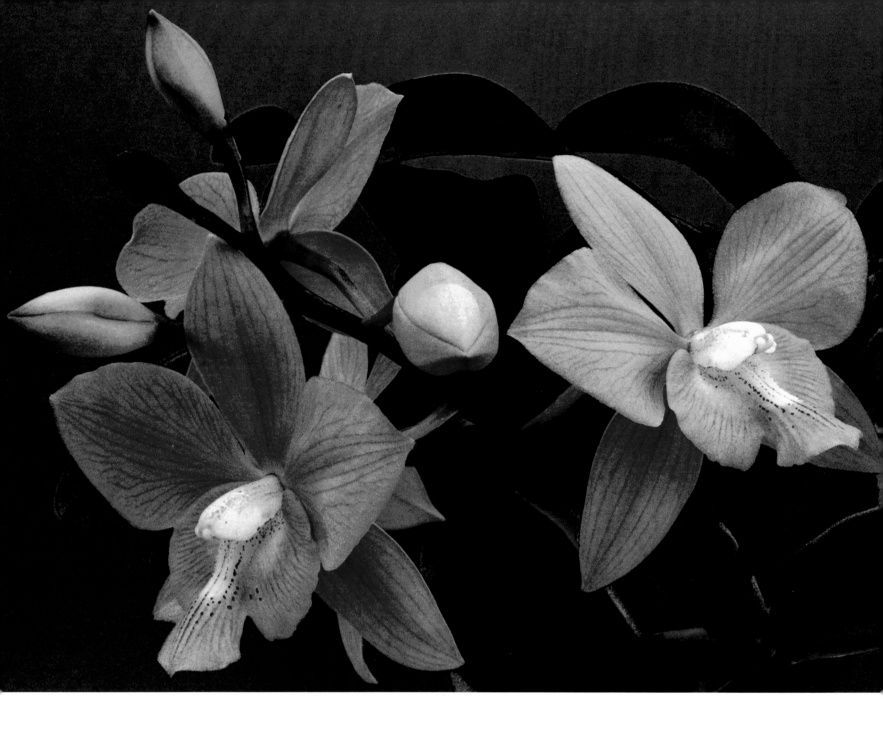

Exquisite pink blooms of a modern orchid
hybrid, doubtless with
Laelia gouldiana
in its pedigree.

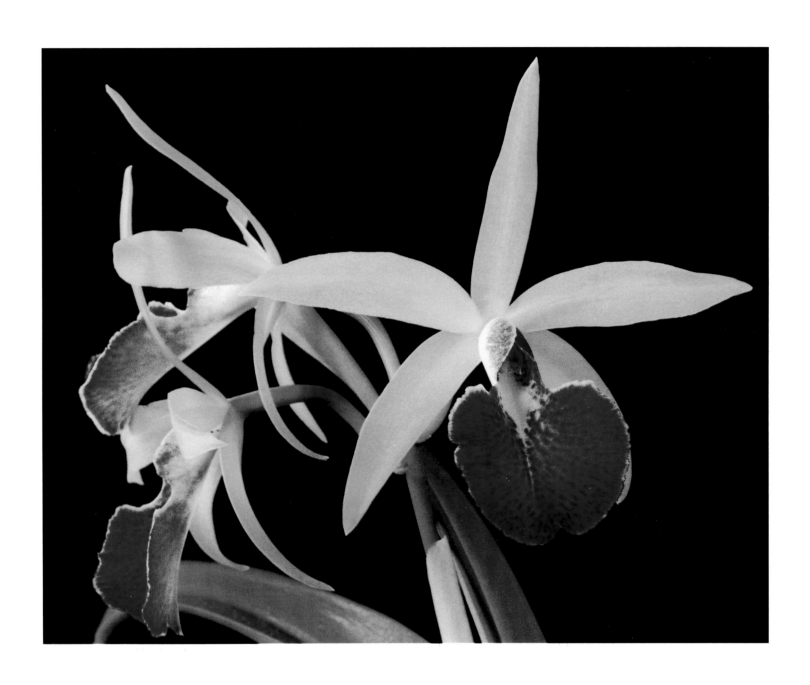

Icy, elegant lime-and-cherry blooms of hybrid
Brassocattleya Binosa × *Cattleya* Brazilian Glow,
a cross of *Brassavola nodosa*. Compare with
the brassocatt on page 98, from a similar (man-made) genus.

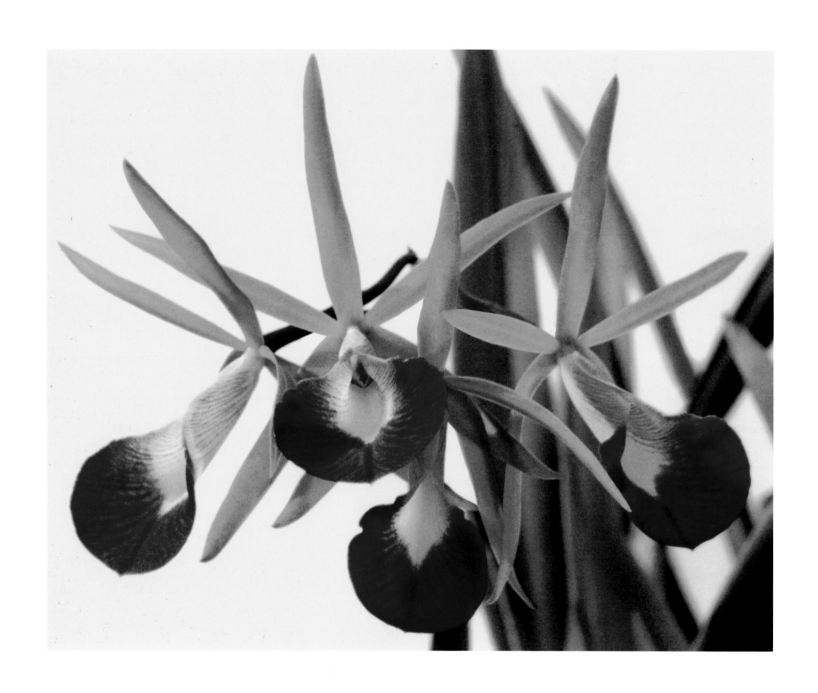

Another cocktail of two genera,
Brassocattleya Star Ruby 'Xanadu'
is half *Brassavola nodosa* and half *Cattleya batalinii.*

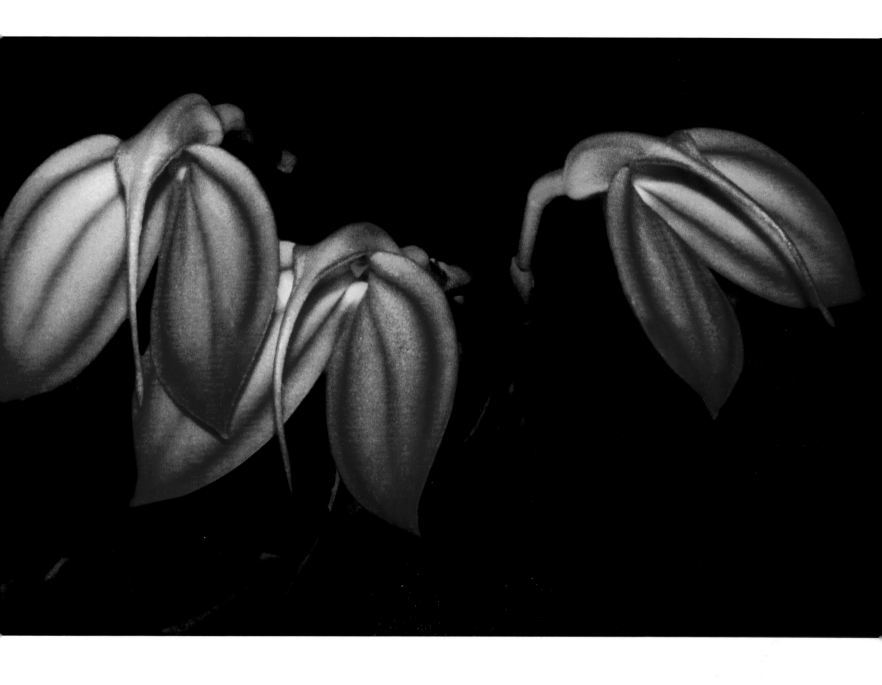

With its nodding sepal tail and scarlet wings,
Masdevallia ignea
looks like a pollinating hummingbird. Native to 10,000-foot elevations
of Colombia, this species prefers cool conditions, with even moisture
and humidity and a bit more light than many masdevallias.

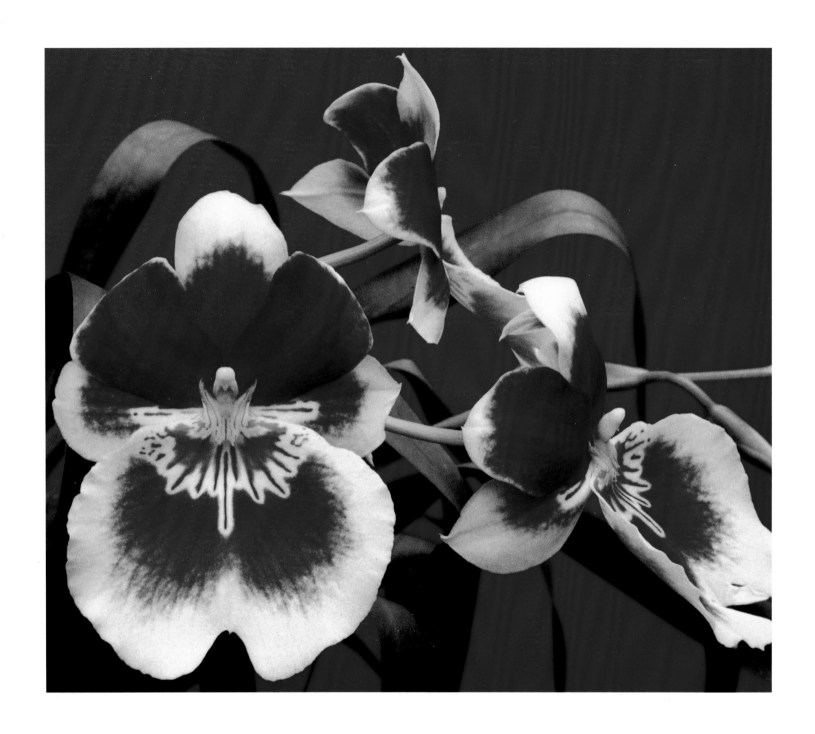

Miltoniopsis Limelight 'Imogene Smith'
is a hybrid of two species pollinated in their native habitat
by butterflies, which are presumably attracted by their likeness.

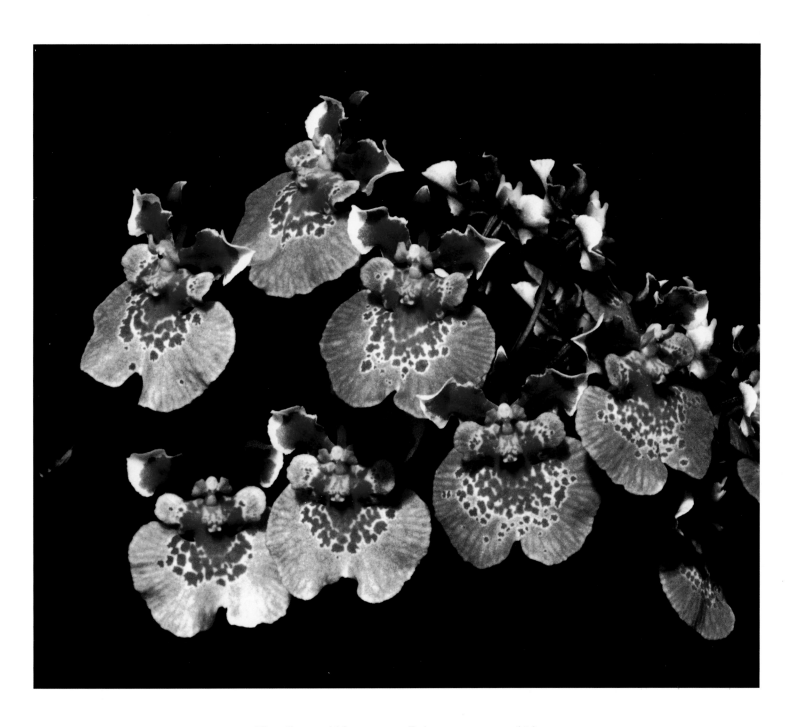

Hawaiian orchid growers call these popcorn orchids
because the flowers just keep popping out. This explosive inflorescence is
Oncidium Golden Sunset 'Sundew',
classed as an equitant miniature hybrid.

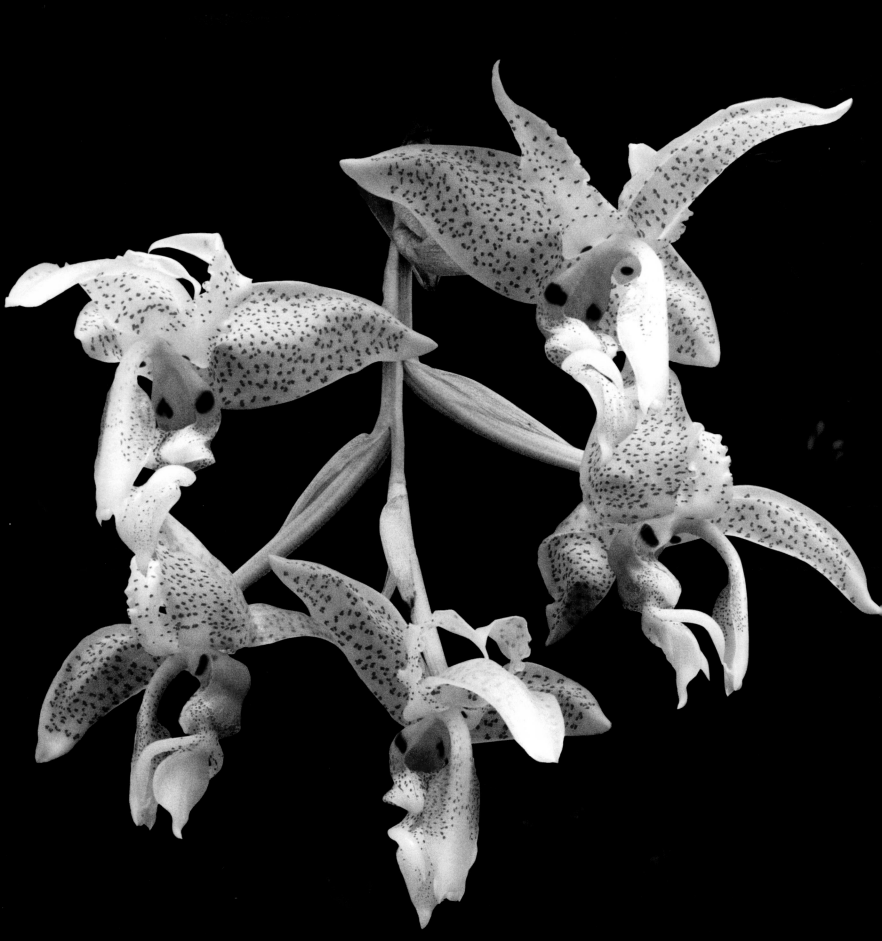

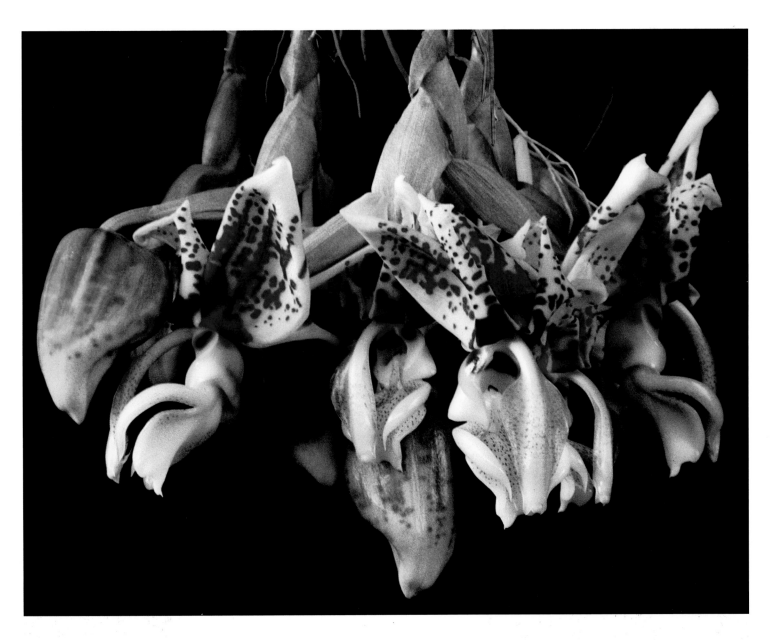

Stanhopea wardii, native from Nicaragua to Venezuela and Peru, has a complicated, sculptural quality, and a pungent odor. *Stanhopea* blooms, unlike those of most orchids, are short-lived. Pendant specimens like these are often grown in hanging containers, or on a stand, the better to admire them.

◀

The showiest of its genus, *Stanhopea tigrina* is intensely fragrant and vividly striped, a dramatic if short-lived subject. The genus is noted for its eccentric growth habit, in which flower spikes develop from the base of the pseudobulbs, descending through the planting media to make a pendulous display. Open-sided boxes made of teakwood slats or moss-lined wire baskets are vessels of choice for these exotic specimens.

▲

Welcoming maw of a red-flowered
Trichopilia marginata;
the genus is known for its long-lived, relatively easy-to-grow flowers.

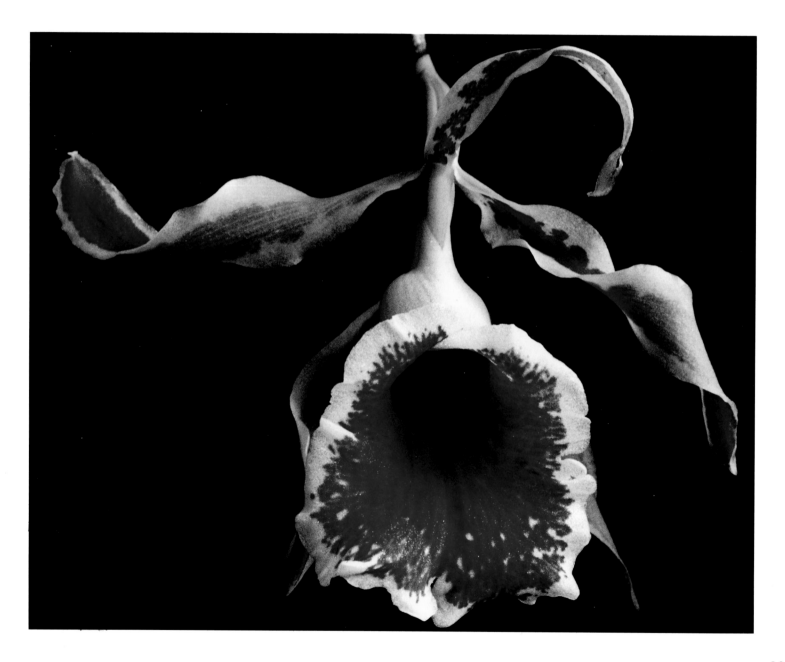

This mildly fragrant species, *Aeranthes grandiflora,* is endemic to humid forests of Madagascar. This translucent yellow-green bloom has been colorized to bring out its deeper gold tones.

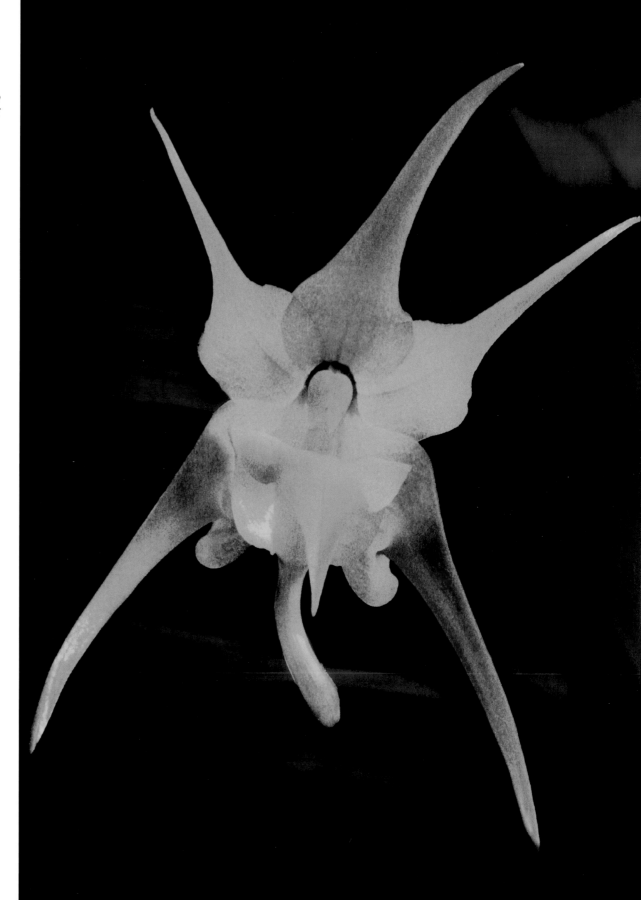

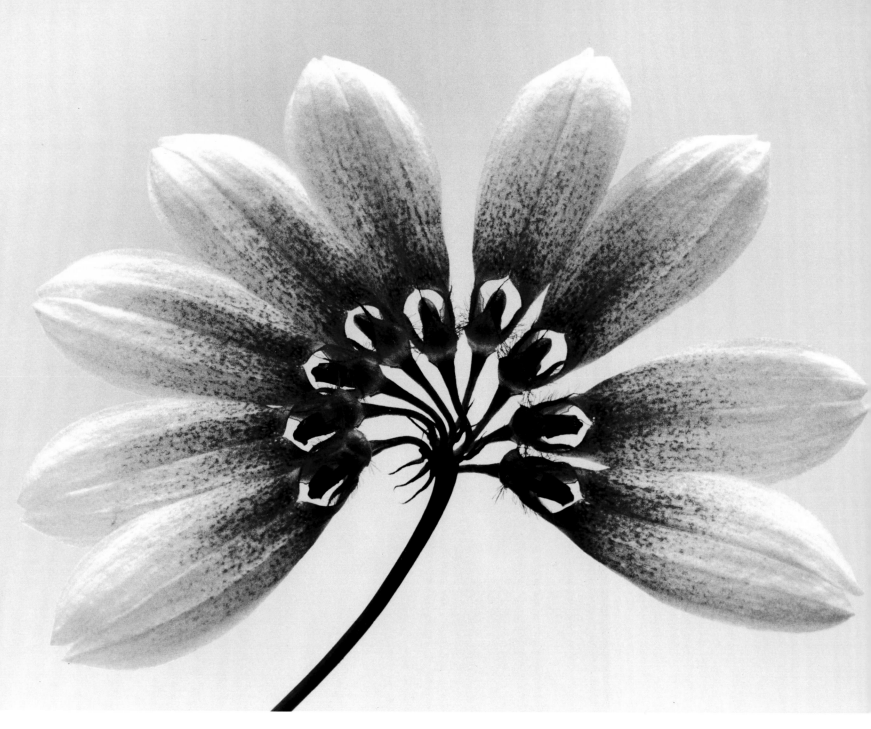

Cirrhopetalum Daisy Chain 'Woodridge'
is a cross of *C. makoyanum* and *C. amesianum*. The fanlike arrangement
suggests Egyptian palms; in a breeze the tiny anther caps rock back
and forth, a dynamic lure to pollinators.

▲

Handsome, well-grown specimen of
Cirrhopetalum makoyanum.

▶

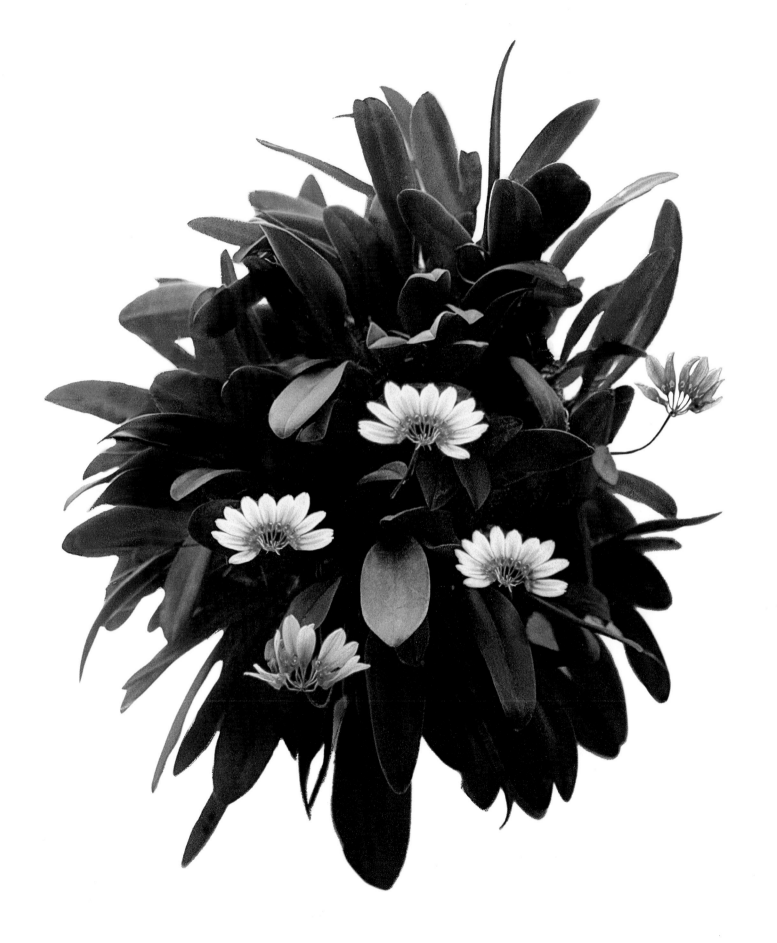

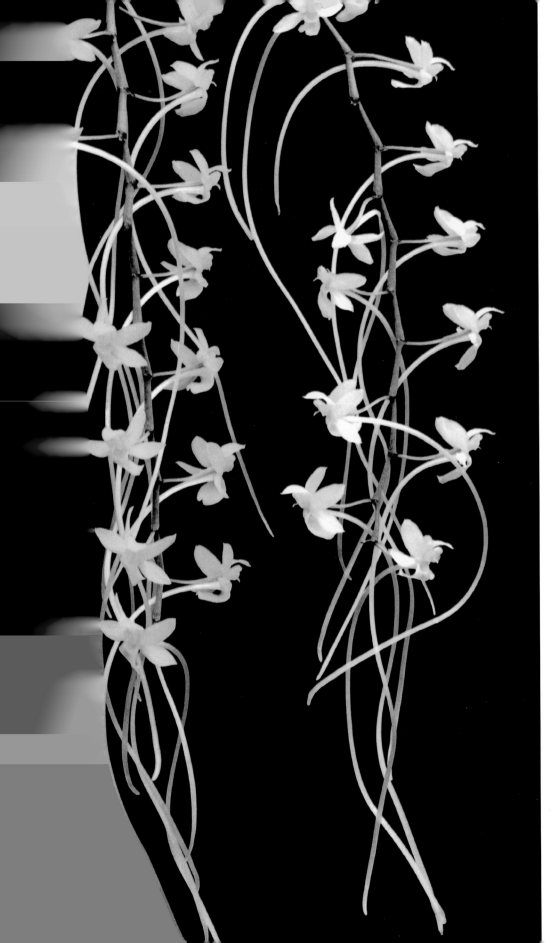

Gold and white versions of graceful
Aerangis mystacidii,
a native of southern Africa and Madagascar
that is coveted for its exotic shape
and pleasing fragrance.

Male swan orchid, *Cycnoches ventricosum,* is intensely fragrant and somewhat aggressive, with spring-loaded, preglued pollinia to ensure pollen delivery. Fingerlike projections on female flowers are designed to detach pollen. This species was first collected in Guatemala in 1837.

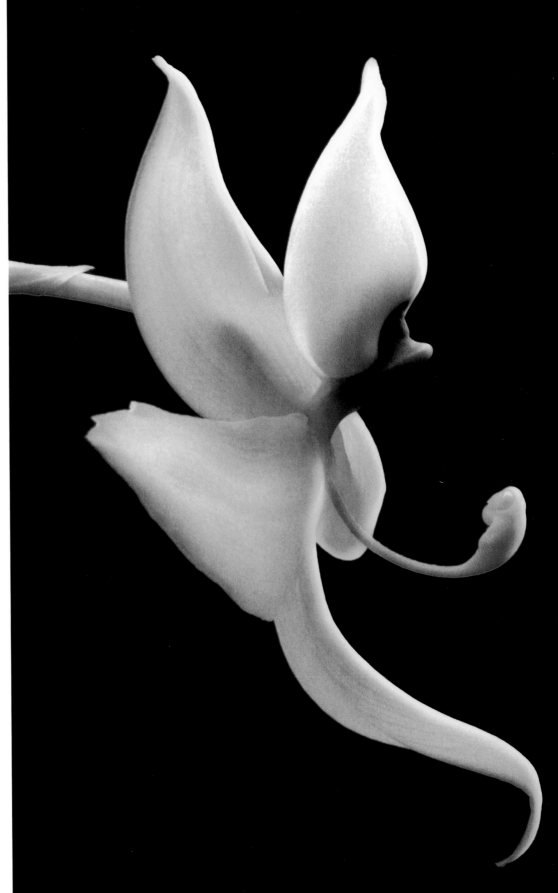

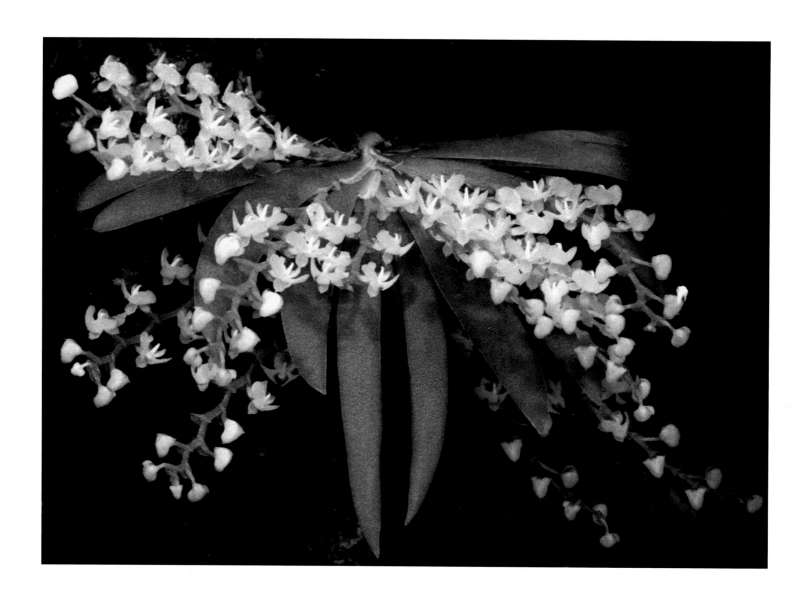

Diminutive
Ornithocephalus gladiatus,
only six inches high, has all the quiet
charm of lily of the valley.

▲

Night-blooming
Brassavola tuberculata,
very similar to the better-known *B. nodosa,* is
native to Brazil, where it has long been
prized for its exquisite sweet fragrance,
reminiscent of apple blossom.

▶

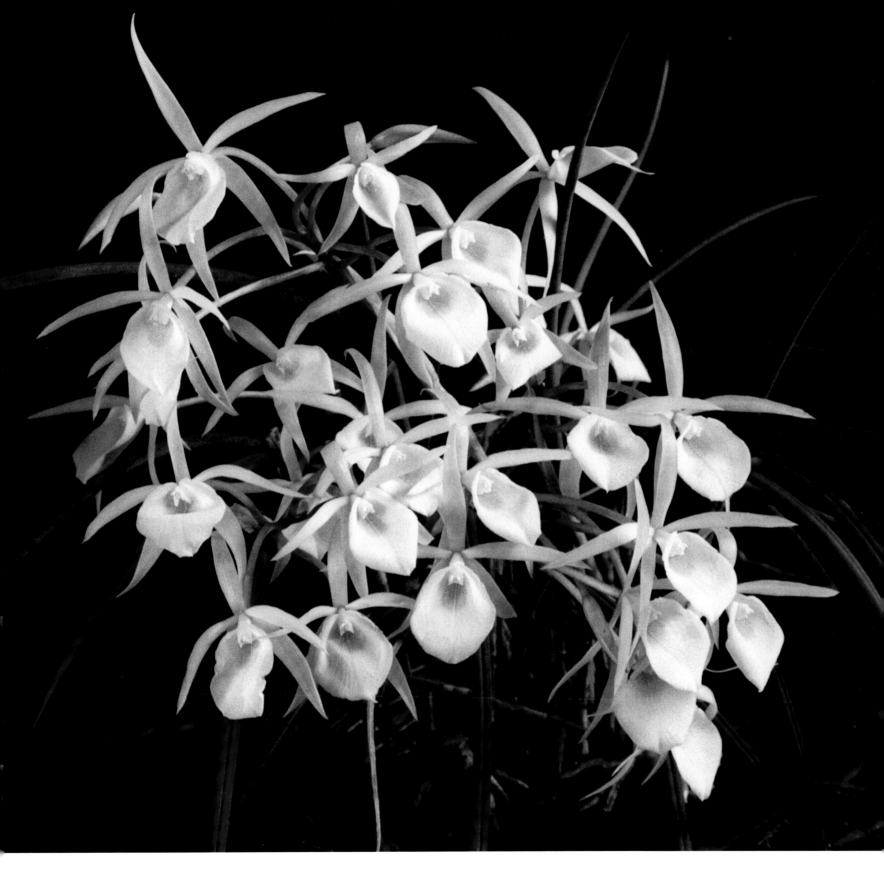

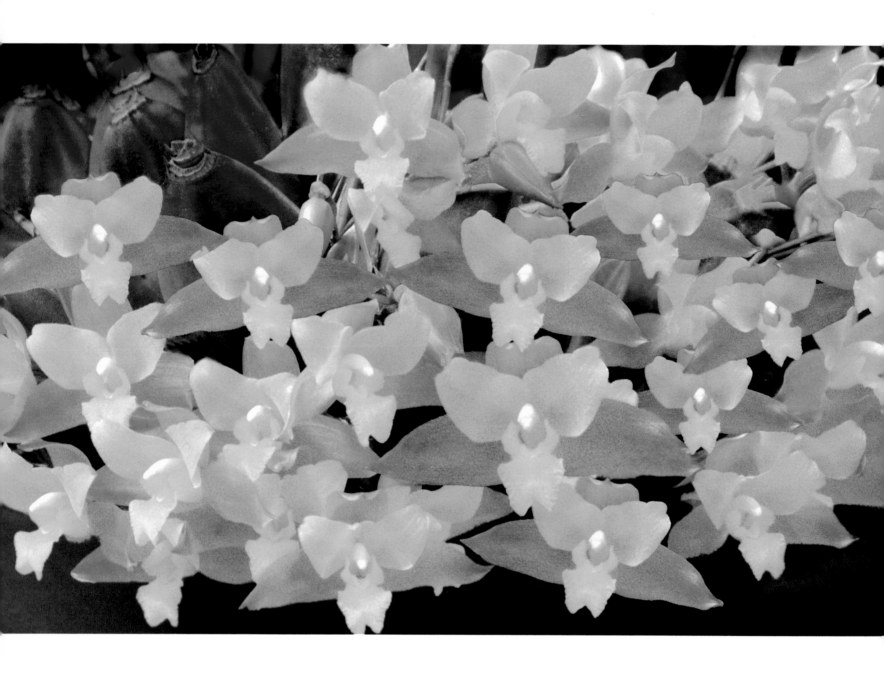

Lycaste Pixie 'Trident Golden Beauty'
produces five to six blossoms on
each pseudobulb of flowering size.

▲

Handsome
Mendocella grandiflora
ranges in nature from Mexico to Colombia.

▶

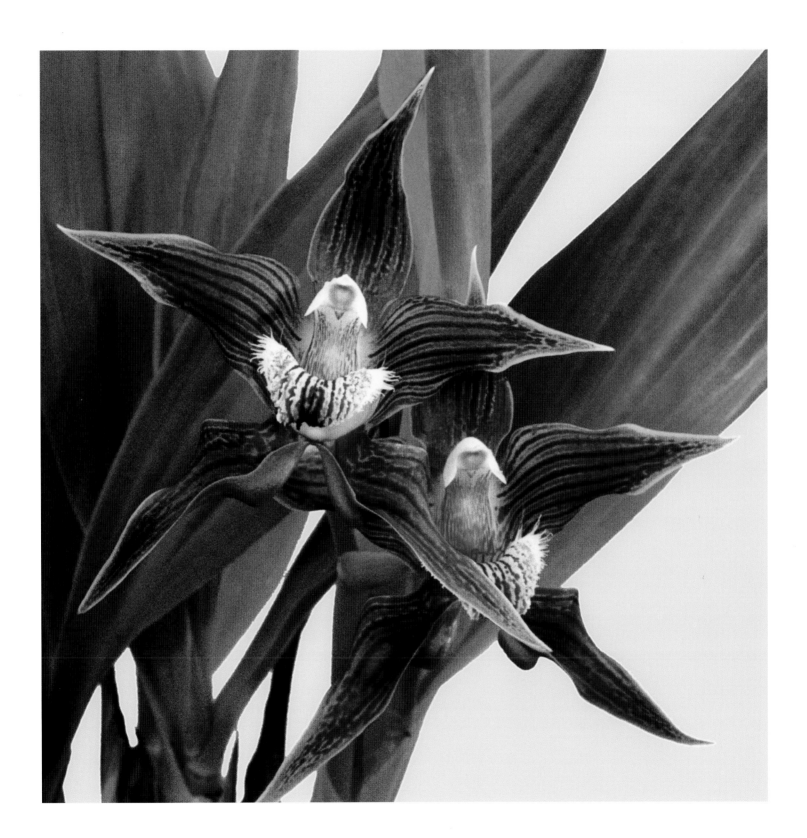

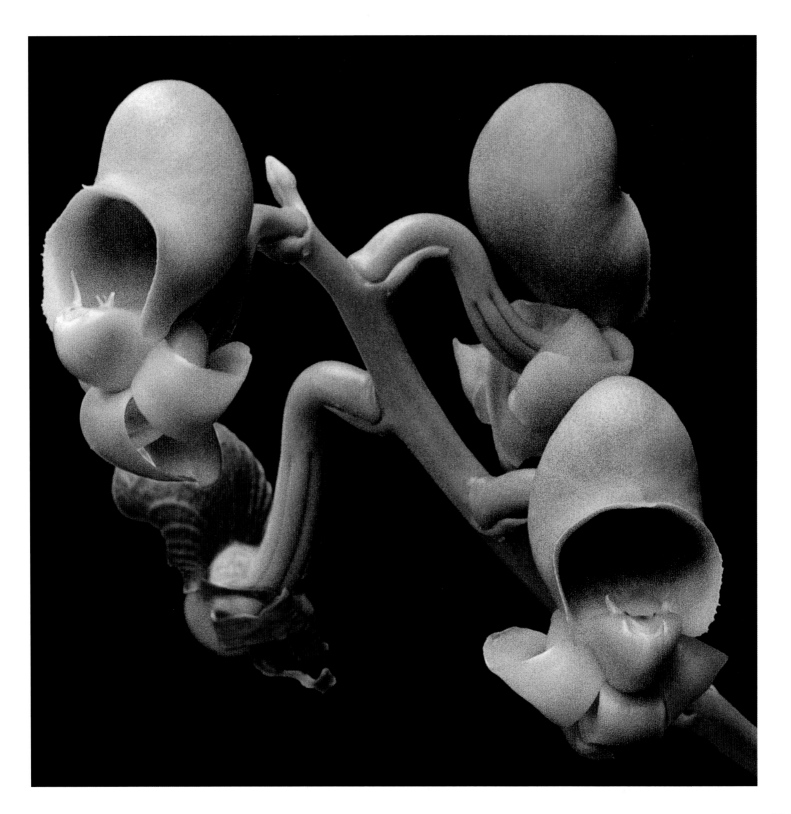

The female, or pistallate, flowers of this
Catasetum expansum
look like green garden clogs for dolls.

◀

The fancied resemblance of
Peristeria elata
to tiny doves exalts the Holy Ghost
orchid to legendary status as the national
flower of Panama. The entire blooms
have a substantial, waxy quality, like giant
white buttercups or tulips; they should
be better known for their horticultural
beauty alone. Though it likes moisture
in growth, the plant can withstand nearly
drying out after flowering is finished.

▶

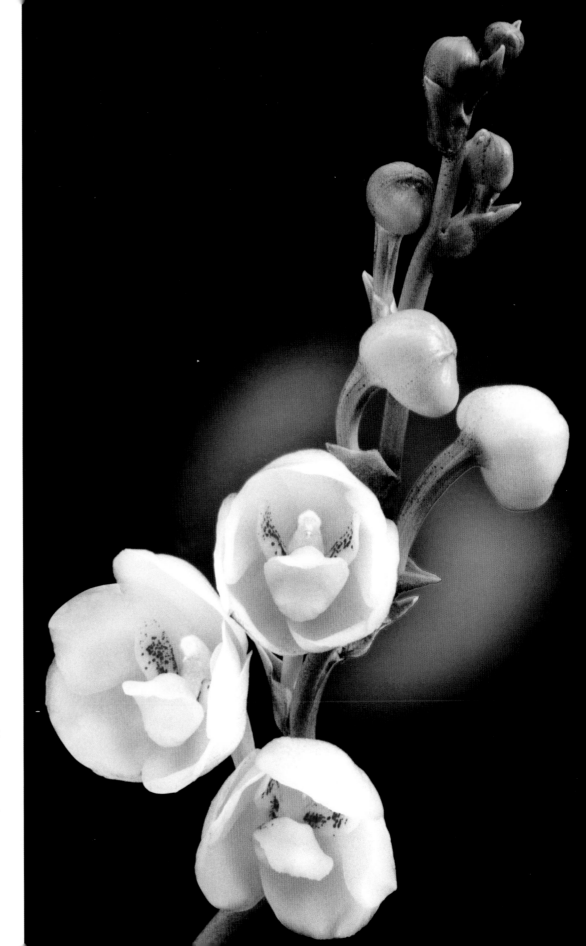

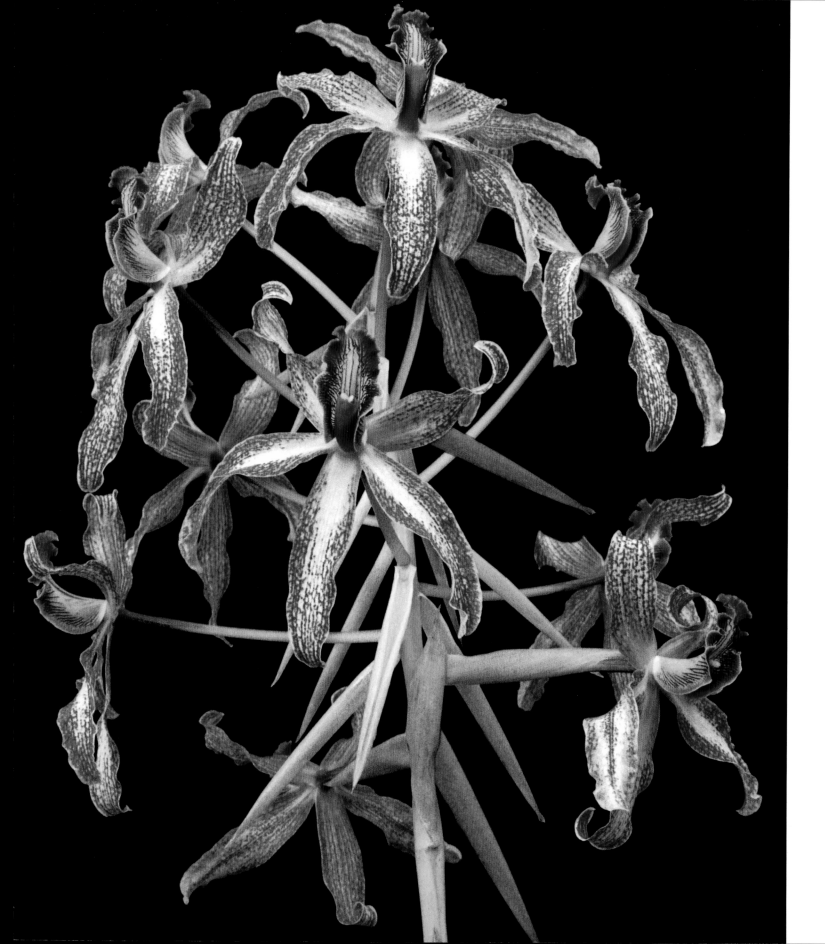

Orchid grower and florist Victor DeRosa named this rosy five-foot-tall hybrid *Schomburgkia* 'Bella Victoria', after his granddaughter. The cross was made by orchid hobbyist Walter Hunnewell of Wellesley, Massachusetts.

◄

Braided platinum pigtail is a stalk of white *Spiranthes,* a native terrestrial, which grows in Mariko Kawaguchi's backyard on the island of Martha's Vineyard, seven miles off the Massachusetts coast. It blooms there in late summer. Wildflower enthusiasts might find more orchids to admire if they looked for small-flowered orchids in open fields.

▶

Brilliant Costa Rican *Stenorrhynchos speciosum* cross has much in common with its pale northern kin.

▶

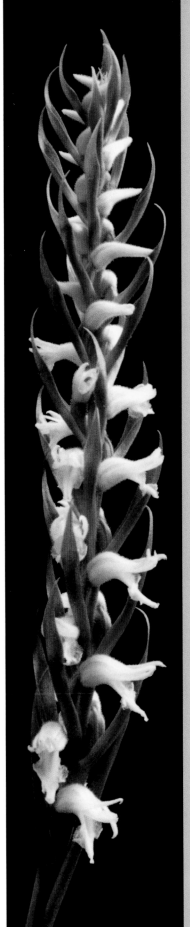
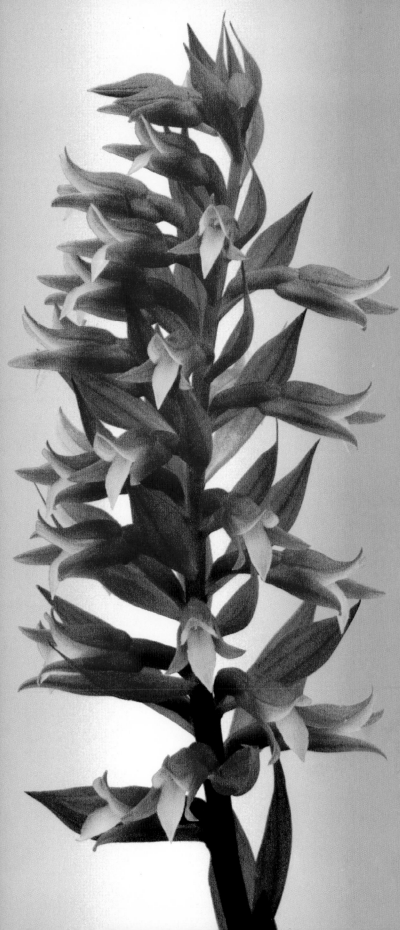

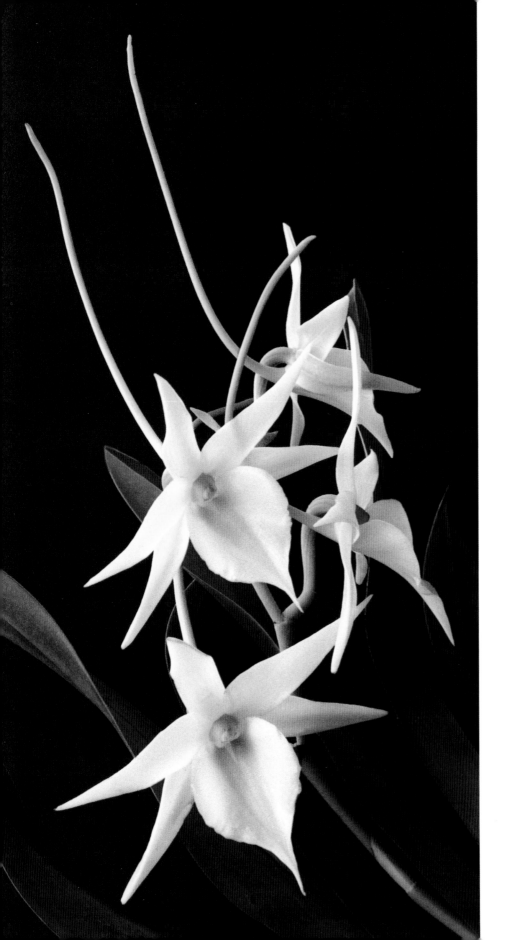

This moonlit confection is pristine
Angraecum Veitchii,
a hybrid of *A. sesquipedale*
and *A. eburneum*. It was a long-spurred
flower just like this one that caused
Darwin to correctly speculate that
Angraecum sesquipedale must be polli-
nated by a moth with a ten-inch tongue.
So confident was he that he named the
moth *Xanthopan morgani praedicta;*
decades later, discovery of the obscure
nocturnal insect proved his theory!

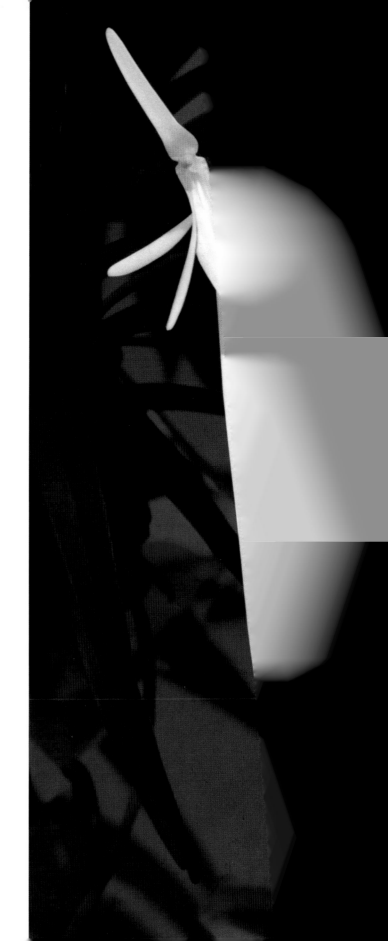

Portrait of
Jumellea sagittata,
a lithophytic (rock-dwelling) species named for the
French botanist Henri Jumelle. Another white-
flowering genus from Madagascar, *Jumellea* was
once classed with *Angraecum*.

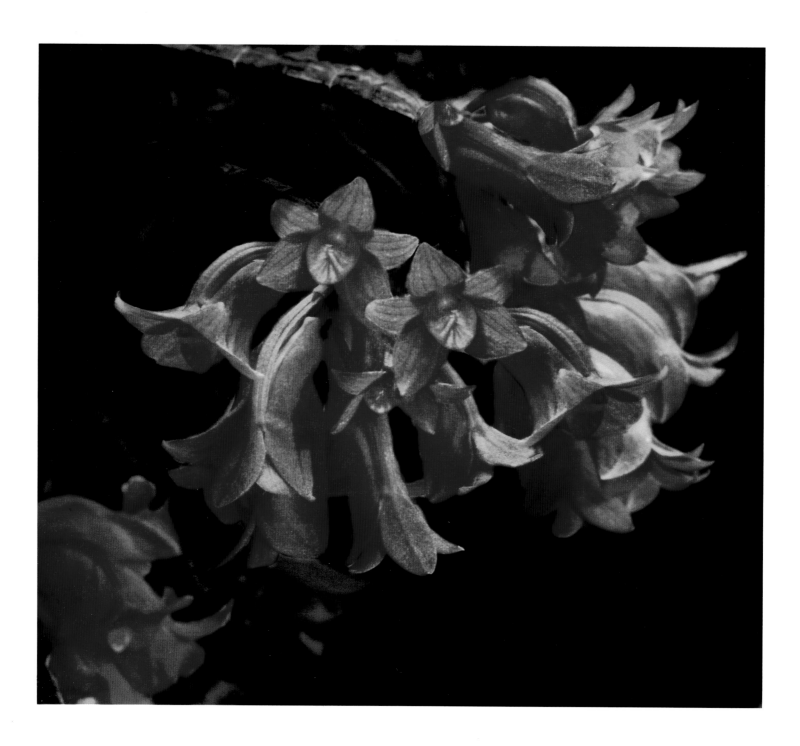

Ruby-red
Dendrobium lawesii
is native to New Guinea and coveted for its small bright facets.

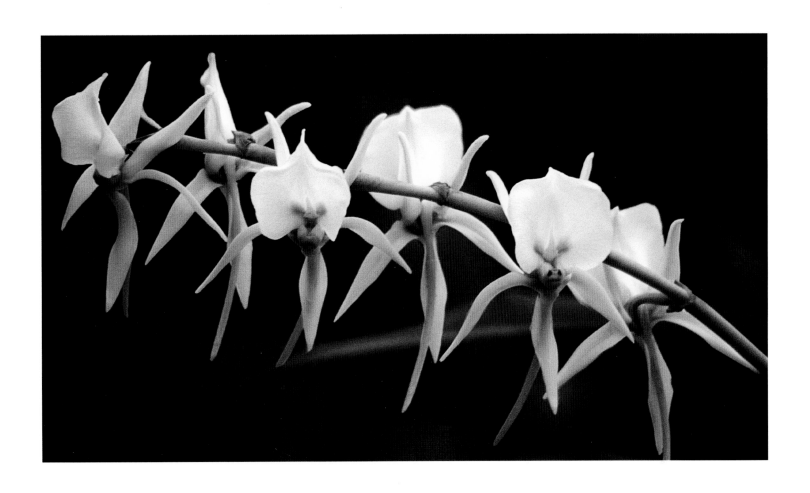

Spicy, aromatic
Angraecum eburneum
fills a room with fragrance in winter, when the long-lived arching sprays
of substantial waxy flowers open. The long green spurs of this Madagascar native hold
sweet nectar, rewarding the pollinator who can reach it.

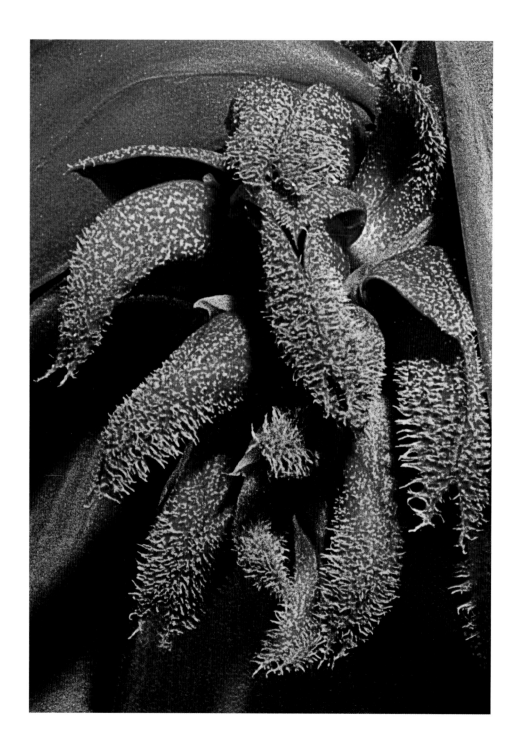

Animal, vegetable,
or mineral?
*Bulbophyllum
phalaenopsis*
has an unpleasant odor —
but undeniable appeal to the
hobbyist looking for
something offbeat.

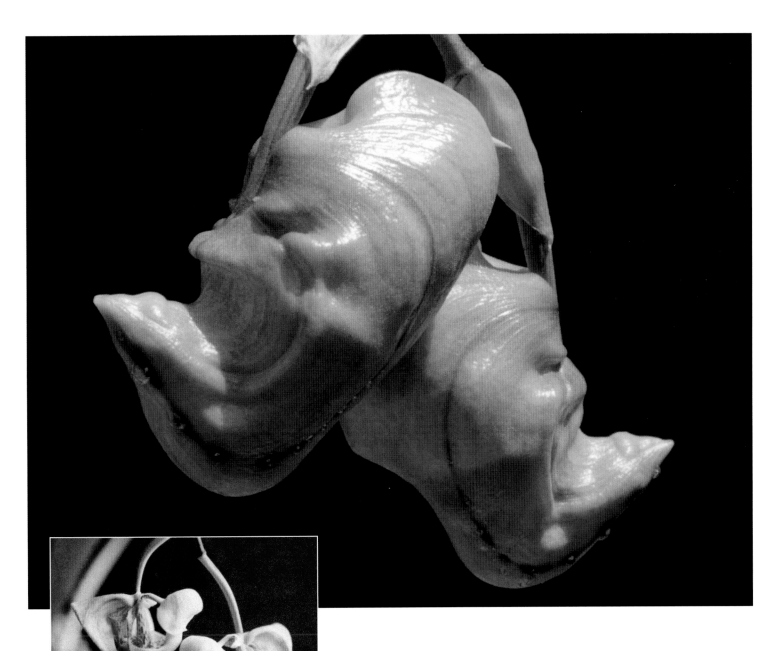

Closed buds of
Coryanthes speciosa.

Where the impatient grower sees an unopened flower, the photographer sees masks of tragedy and comedy. *Coryanthes* means "helmet flower" in Latin. Its common name is bucket orchid, because the cuplike opened flower (inset) quickly fills and becomes a slippery, nectary reservoir — yet another ruse by which orchids make insects assist with reproduction.

Two speckled blooms of
Promenaea stapelioides
have a Moses-in-the-bullrushes character.
Though it is named after a group of flowers
(in the genus *Stapelia,* of the milkweed family)
that have carrion-like coloring and odors
and are pollinated by flies, these counterintuitive
blossoms have a pleasant fragrance.

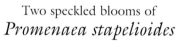

Oncidium wyattianum
is unusual for its type; without
the characteristic mahogany bars
that most oncidiums have,
it looks almost like a miltonia.

▶

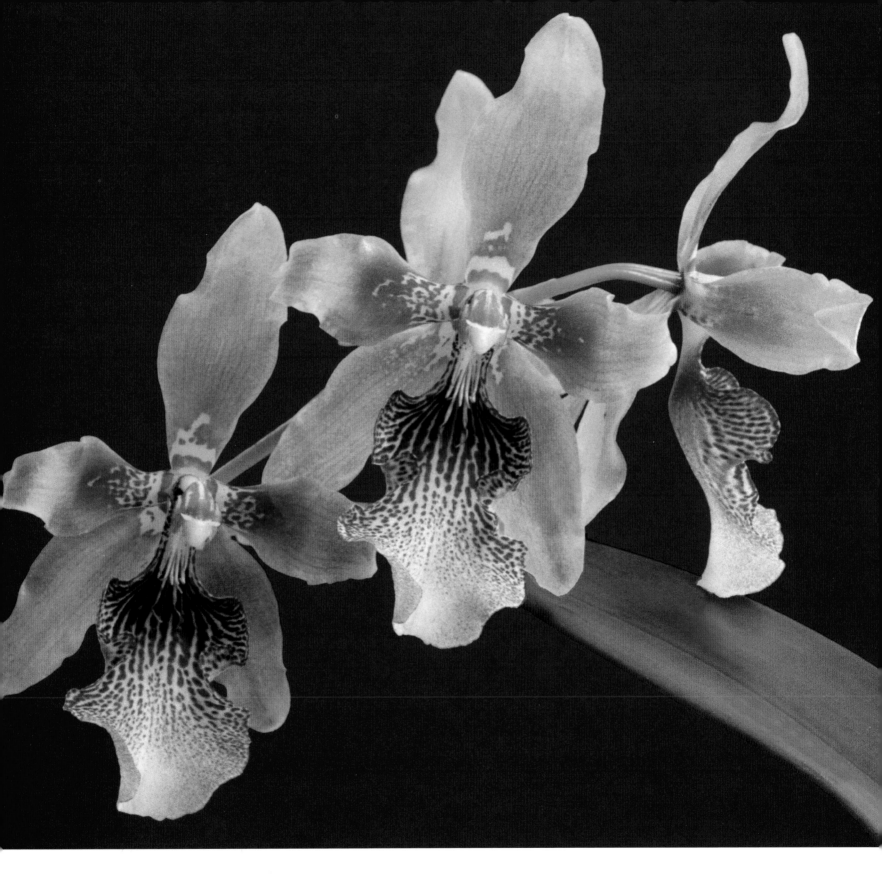

A Brief History of Cultivated Orchids

The reign of orchids is old and vast. In both the East and the West, their history is intertwined with early scholarship, and they are mentioned in some of the earliest writings from the New World as well.

In Asia, where the invisible aesthetic of fragrance is still central to the ideal of a beautiful orchid, these plants have tended to symbolize refinement, perfection, and purity, as well as fertility. It seems particularly fitting that the ethereal *lan,* the sweet-scented orchid we know as *Cymbidium ensifolium,* is written of in that revered text of philosophy the *I Ching,* as early as 500 B.C.

In Western culture the word *orchid* can be traced to the ancient Greeks; oddly, their word *orchis* meant "testicle." This was undoubtedly an earthy reference to the distinctive shape of the paired, tuberous roots of a terrestrial Mediterranean species, in the genus known to us by the same name, *Orchis.* The philosopher Theophrastus, a student of Plato and Aristotle, mentioned these flowers in a treatise written about 300 B.C.

He was followed by the Greek botanist Dioscorides in the first century A.D., best known for a theory called the doctrine of signatures. Following this line of thought, if a plant looked like part of the human anatomy it was logical to assume it healed disorders or complaints of same, or some such. Thus the remarkable *Orchis* tubers might prove to be an aphrodisiac, a fertility drug, or even a cure for venereal disease. Though the reasoning eventually proved faulty, related orchids were to preoccupy herbalists through the Middle Ages; by 1561, about thirteen types were known to Europeans.

These man-made hybrids, featuring compact growth for windowsill growing, are both brilliant in color and miniature in scale.

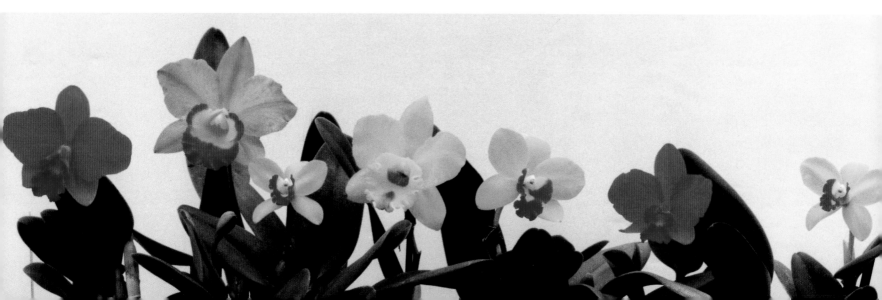

Vanilla was very likely the first tropical epiphyte brought back from the New World, as early as 1510. (Epiphytic orchids cling to trees rather than growing in soil.) The record of Aztec cultivation of the plant in Meso-America can be found in the 1552 herbal manuscript known as the *Badianus*. And the Elizabethan John Parkinson, in quest of new medicinals abroad, described the terrestrial lady's slipper in his seminal 1640 work, *Theatricum Botanicum*, on his return to England from North America.

The seventeenth century was a time of great change. Exploration of new lands and expansion of empires — especially in orchid-rich Latin America and Southeast Asia — would bring new, fascinating plant material for naturalists, botanists, and horticulturists to study. At the same time, superstition and folk knowledge about plants began to give way to scientific inquiry and observation. Illustrators returned to drawing detailed images of plants from life, instead of copying from older books as they had for so many centuries. And, increasingly, the printing press and new methods of illustration were changing the means of communicating information about the brave new world of plants.

By 1740 the Swedish-born father of modern botany, Carl von Linné (his Latinized name is Linnaeus), had published a technical work that described the handful of orchid species known at the time in Europe and England. By 1753 he had developed a new system of classification of plants based on their sexual, or flowering, characteristics; it is more or less the method we use today. His ingenious system also allowed for every new species of plant to have a distinct, two-word Latin name, which combines the genus name (the first word) with a specific epithet. Without it we couldn't talk sensibly about orchids, or any other plants.

In any case, it is fortunate that the Linnaean system was in use before the thousands of tropical epiphytic orchids began to pour into England and Europe from all corners of the world during the eighteenth and nineteenth centuries. Throughout the West Indies, Mexico, and South America, adventurers were discovering a wealth of intriguing orchids that grew on trees. Those who ventured east would find still more species in Java, India, Burma, and the Malaysian archipelago, and in the islands of the South Pacific, New Guinea, New Zealand, and Australia. The earliest orchid finds abroad may have been incidental, brought back as they often were by entrepreneurs seeking other treasure. But as enthusiasm for orchids grew, the plants themselves would become the bounty.

The specimens of *Cattleya, Cymbidium, Dendrobium, Miltonia, Oncidium,* and *Phalaenopsis*

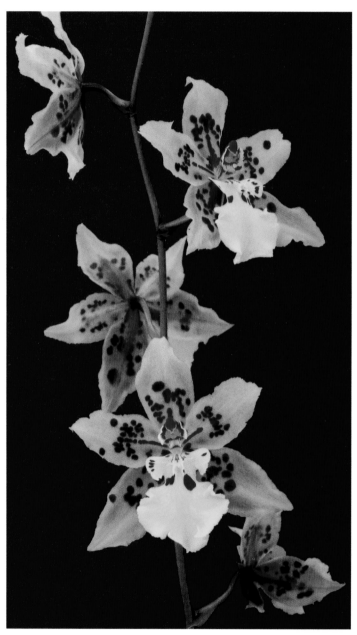

Odontocidium Purebeck Gold, the joyful offspring of *Oncidium tigrinum* x *Odontoglossum* Gold Cup.

orchids they brought back were to become the ancestors of the cultivated greenhouse orchids that are the primary subject of this book — and still the mainstay for hobbyists and commercial growers alike. These tropical epiphytes all thrived on living trees in their native habitats, which easily explains why they are grown mounted on coarse bark or in a compost of fir bark. Their tree-house lifestyle led early growers to believe that such plants might be parasitic, though this is not the case.

Later discoveries of the exotic slipper orchids, like Asian cypripediums and paphiopedilums and Andean phragmipediums, proved intriguing variations of their European kin. Though more inclined to grow in a soillike medium, they likewise proved a challenge to cultivate.

It would take years before all these new orchids would be well understood, and there were many losses in the heyday of English and European plant collecting. Thousands of specimens died on board ship, like miserable immigrants consigned to steerage. Others succumbed to ignorance; unknowing gardeners potted them up in unsuitable compost and stuffed them into dingy over-heated "stovehouses." Gradually, though, gardeners paid more heed to the conditions orchids inhabited in the wild. The well-equipped and well-educated Joseph Banks set sail to the South Seas with Captain Cook in 1768, an ambitious three-year voyage that brought back spectacular plants, and initiated a new approach to collecting. In 1780 Banks returned from another voyage to the region with the first Australian orchids, brought back to England on the H.M.S. *Endeavour.*

Eventually, more enlightened, scientific practices in orchid growing began to take hold. The first breakthrough came when *Encyclia cochleata* bloomed in cultivation in a greenhouse at Kew Gardens, outside London, in 1789. By 1813 about sixty species of exotic orchids were growing at Kew, but only a few were

epiphytes. In 1819 beautiful *Cattleya labiata* flowered for a collector named William Cattley, one of many English orchid patrons immortalized in the names of some of the loveliest species.

The next 150 years were to see a blossoming in orchid cultivation, and many more milestones. The English obsession with orchid growing as a hobby got under way in earnest in 1833, when the sixth Duke of Devonshire, William Spencer Cavendish, fell madly for *Oncidium papilio* (now *Psychopsis papilio*). In the same year a spectacular *Oncidium flexuosum* likewise sparked interest when it was exhibited on this side of the Atlantic, at a meeting of the Massachusetts Horticultural Society in Boston.

Orchids soon became a symbol of luxury, and the leisure class feverishly began collecting plants. For the better part of the century the great orchid populations of the world were shamelessly ransacked as the plants fetched astronomical prices at auction in England. Reports of unscrupulous collectors are legion, and even firms and plantsmen whose names we respect today took part in the pirating.

The nineteenth century, especially, was the age of the "lost orchid," when an unbridled mania for new orchids simultaneously created demand while destroying supply. A collector would decimate a native stand of plants unknown in England and return with the goods; the species would die in cultivation — often after a swan song of lush bloom brought on by stress. Subsequent hunters would be unable to locate another in the wild for years, sometimes never.

Thankfully, orchids in cultivation were beginning to yield their secrets. In the decade between 1830 and 1840, the British plantsman and prodigious writer John Lindley systematically described all 1,980 of the species that were known in the world.

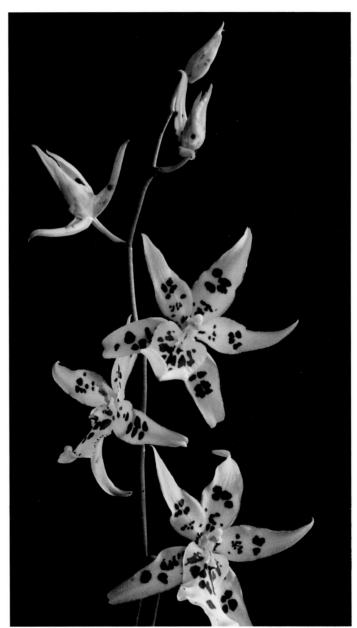

Maclellenara Pagan Love Song, a multigeneric cross of *Odontocidium* Tiger Butter x *Brassia Verrucosa*.

The skilled horticulturist Joseph Paxton methodically explored better means of culture, and published his findings in excellent periodicals. In 1862 a classic work by Charles Darwin, *On the Fertilization of Orchids by Insects,* would begin to explore the hows and whys of coevolution and the mechanisms of orchid pollination.

The craze for wild species would eventually abate with the gradual arrival of fashionable hybrids. In 1856 the first orchid hybrid, *Calanthe* Dominyi, was created from two natural species by John Dominy, the foreman at Veitch's, a prominent Chelsea nursery that then dominated the hybrid scene for twenty years. By 1901 nurseryman Frederick Sanders's comprehensive list of all the known orchid hybrids filled thirty-two pages. Perhaps it goes without saying that most of the orchids that attract hybridizers tend to be large-flowered, colorful, and pleasantly scented.

In the twentieth century several other scientific advances paved the way for the expansive world of cultivated orchids we know today. Around the turn of the century, a young French biologist, Noel Bernard, and a German professor, Hans Burgeff, working independently of each other, were the first to understand that the presence of fungi in orchid roots was not an infection but a symbiotic relationship by which the fungus converted starches to sugar in a form the young plant could use.

It is easy to see why the many peculiarities of orchids baffled the horticulturists of yesteryear. Though no other flower produces seeds in such abundance, orchid seeds lack the nutritional endosperm that gives young seedlings of other plants enough nourishment to sustain themselves until they can develop roots. The seeds of orchids must find midwife and nurse in a compatible fungus to manufacture food in a useable form. And when they do grow, orchid seeds take their time, sometimes several years to develop into a visible plantlet and an average six to eight years to flower. Propagation on any scale had always been an impediment to growers.

In 1917, working with Bernard's discovery, Lewis Knudson, a young botany professor at Cornell University, found a way to bypass the fungus connection by providing orchid seeds with a sterile nutrient medium. His practical investigations helped to launch orchids as a profitable cut-flower and potted plant industry, creating a means by which orchid seeds could be grown by the thousands under controlled conditions. The American Orchid Society, founded in Boston in 1920 and guided by the brilliant orchidologist Oakes Ames, shortly thereafter

became an important source of information to hobbyists and a repository of scientific findings as well.

Sadly, the ravages of both world wars set back orchid cultivation in England and Europe. Collections were ruined, records destroyed, heirloom plants neglected and lost forever.

Large-scale cultivation of orchids was to remain a labor- and time-intensive industry until 1960, when the French agriculturist Georges Morel developed a method of cloning orchids through culturing stem tissue. This allowed for a quicker method of culture, and more control over seed-borne viruses. Best of all, the clones promised to be exact copies of the parent plants. And over the last thirty years, advances in genetic engineering have allowed hybridists an even finer tool in designing orchids for hobbyists. Southeast Asia and Hawaii have become important regions of orchid research and cultivation, and air freight gets them distributed throughout the world quickly. Today an orchid, once a rarity available only to the wealthy, is as accessible to the masses as any houseplant or cut flower.

In a happy irony, our understanding of orchid biology, and our knowledge of the means to grow them in greenhouses and on windowsills, is finally serving the wild species. Hybridists like Mariko Kawaguchi share their expertise with conservationists and are finding ways to propagate wild orchids in the laboratory — and to replenish the fields and forests where once so many more prospered.

— Rosalie H. Davis

The Art of Hybridizing Orchids

Humans have put their signature to the expression of their own sense of beauty in hybridizing orchids. Similar to a painter with an empty canvas, and using pollinia from one of the largest plant families in existence as a palette, hybridizers combine imagination with botanical skills to bring new colors, shapes, and patterns to life.

In modern orchid breeding insects, bats, and birds — the natural pollinators of orchids — have been replaced by tweezers, transfer tools, and ambition. A hummingbird transporting pollen on its body cannot fly beyond its physical endurance and habitat. But geographical dis-

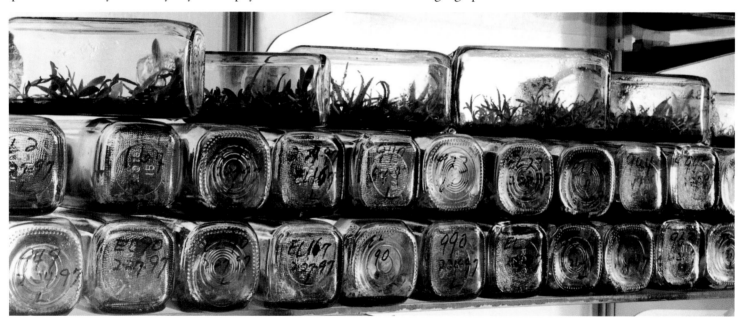

tances disappear when humans intervene in artificial pollination. One sweep of the breeder's hand can transfer the pollinia hidden beneath the anther cap of an orchid species originating in the New World to the stigma of a receptive species from the Old World.

I remember many years ago following my mentor, Victor DeRosa, around his seedling greenhouse. He always had a distracted expression on his face as he was looking for the first flowers of crosses he had made years ago. I was privileged to know the inner thinking of this self-taught orchid man. The first activity of his hectic day was the seedling walk he took in his

Numbered, sterile bottles stacked in the tissue culture lab are home to a hundred thousand seedlings awaiting the next phase of greenhouse cultivation.

132

greenhouse. It was his quiet time, an everyday discipline, a moment of contemplation. On one occasion he shared a personal inventory of friends who were the stalwarts of the orchid-breeding frontier of their era, people who had now passed on. He told me their tales, not only in words, but also with the flowers that stood as living reminders throughout the greenhouses — tales of the trials, rivalry, and excitement that made for a lifetime of adventure in hybridizing orchids. As the years followed, we passed many flowers together on the early morning walks; now their history has become entwined in the next orchid generations. It was Victor DeRosa's childlike enthusiasm in looking for another flower tomorrow that made me want to be like him, to dedicate my life to breeding orchids.

Most visitors to an orchid greenhouse are fascinated at the unique process of growing orchids in a laboratory. One does not obtain orchid seed packets from the rack in the local hardware store in the spring, as you would tomatoes and petunias. An orchid's seedpod may contain up to a million microscopic seeds; when fully ripe the swollen capsule will turn yellow and split open, broadcasting the lightweight contents into the wind. Seeds of most other plants have a protective coating that contains food reserves to sustain them in the first stages of their awakening, but orchid seeds are incapable of germination on their own because they lack sufficient nutrients to start the process.

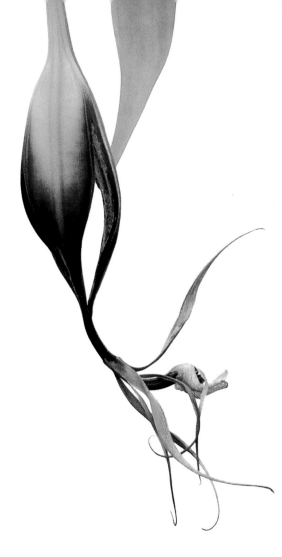

In the wild a symbiotic relationship is formed with the presence of a mycorrhiza fungus in order to produce the food that stimulates germination. This important connection was recognized in 1899 by a French botanist, Noel Bernard. Given the thinking of the time, many orchidists assumed seed from these elite flowering plants were sterile. Bernard's research allowed small-scale seed propagation to commence. Ripe seed was dispersed on a bed of moist sphagnum moss at the base of the mature plant, in hopes that the specific fungus was growing near the root tips. Careful watering and parental vigilance often met with a few offspring. Later steps included the growth of specific fungal mycelium in test tubes to be introduced into another plant containing the ripe seed.

A ripening seedpod, which when it splits will release some one million orchid seeds into the wind. For seed to germinate in the wild, the presence of a mycorrhiza fungus is necessary.

A giant advance in the modern commercial cultivation of orchids was the introduction of the Knudson formula, which enabled asymbiotic lab techniques to be used for the reliable growth of orchids from seed. In 1917 Lewis Knudson, a plant physiologist at Cornell University, isolated the complex salts, sugars, and minerals the fungus would have provided in nature. The need for the specific fungal hyphae was bypassed using this formula. With these components

suspended in sterile agar, all of the nutrients are available to enrich the seeds into the next growth level, called protocorms.

A tissue culture lab setup has a Laminar flow hood; this enclosed sterile workbench allows prefiltered air to go through the space to keep materials free from contaminants. A sterile environment is necessary to do the sensitive work of seeding a ripe pod for in vitro culture. Special microscreened HEPA filters keep out unwanted bacteria, mold spores, and unwanted fungi. The seedpod is taken from the mature plant before the pod has split.

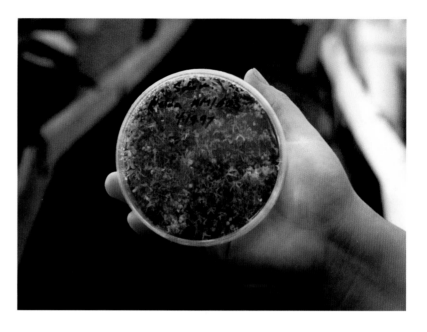

An award-winning cross of *Schomburgkia* 'Nelda' has germinated in this sterile petri dish. Complex salts and sugars in an agar base have provided the essential nutrients that only a fungus can provide in nature.

This method of propagation is called green pod culture. The pod is surface-sterilized chemically with a solution of chlorine bleach, then immersed in pure grade alcohol, then flamed to ensure the sterile needs of the next steps. The pod is dissected and the seeds are scraped onto the culture medium in a sterile flask; the agar solution is the consistency of gelatin. The bottle is capped with enough cotton to keep out unwanted microorganisms while still allowing gas exchange. At this point, the flask is given an identifying number or the name is logged in the lab book with the cross and all information regarding its genealogy and growth habits. Shelves nearby the lab are kept on a sixteen-hour full-spectrum light cycle. Inside the flasks, microcosms of self-sufficiency, the nutrients, moisture, and filtered air cloister the seedlings till they grow to adolescence. Eventually the seedlings will become overcrowded and need to be replanted in a larger bottle with fresh media.

Another advance that shook the foundations of the orchid world took place in Paris in 1960. Professor Georges Morel began the first program of vegetative multiplication, by the dissection of very specialized embryonic tissues called the meristem. Plants reproduced by tissue culture enabled superior, virus-free, selected orchids to be cloned. The process requires work done in a proper laboratory facility with specialized equipment and chemistry. Duplicate plants could affordably be propagated for widespread distribution and mass production. Professor Morel's discovery revolutionized commercial standards and ushered in social changes that broke the elitist traditions in the purchasing of these plants. The queen of all flowers had chosen to share her charms with the commoner as well as the king.

The fundamental process in making a cross or hybrid is a straightforward one, though it seems endless. Two years of peering at the seedlings in their flask form in the lab are followed by two to four additional years in the seedling house without the reward of a single flower. It requires patient observation to study the variations after the bottle babies begin to bloom. If you are making a cross with two species, you are making a primary hybrid. Within this gene pool you can estimate the variations that should come about from the breeder's intentions. Complex hybrids that have many generations, layering the genetic backgrounds with dominant and recessive traits that are unseen in the pod and pollen parent plants, are unpredictable, and achieving desirable results depends on experience, careful research into the genetic ancestors, and the luck of the hybridizer.

Gene transfer is the next cutting-edge technology that will affect man-made orchids. This is the quantum leap that takes orchids deeper into the laboratory and higher plains of science than most of us growing our plants on the windowsill can go. Imagine orchids that could flower longer, herbicide-resistant orchids that would facilitate weed removal in commercial greenhouses, new colors not found in the species, increased hardiness and vigor: these are some positive genetic alterations most growers would welcome.

The orchid is among the most highly evolved and complex plants in the botanical kingdom, set apart by its complex fragrances, mimicry as sexual lure, and unusual plant devices to assure that the pollinator carries away its packet of pollen on the flight to the next awaiting flower. Orchids are very species specific regarding their pollinators, which makes them especially sensitive to their environment. Responsible science, by helping to protect the fragile ecosystems these plants call home and by continuing to improve techniques of orchid cultivation, can play an important role in expanding the diminished horizons that each new dawn brings.

— Mariko Kawaguchi

Jewels of Denial

Can you imagine a beautiful orchid ready to bloom only to have the nurturing grower's hands pinch off the flowers before the first blossoms open? This group of orchid genera is commonly referred to as jewel orchids. They are grown for their colorful foliage rather than the small white flowers that are produced from the center of the impressive display of leaves; they are often overlooked in orchid literature because of the focus on large hybrids that dominates the stereotype of what orchids look like.

Jewel orchids are a spinning taxonomic wheel of interchangeable nomenclature; for example, *Ludisia discolor* is also known as *Haemaria discolor* and *Anoectochilus discolor. Dossinia, Erythrodes, Goodyera, Zeuxine,* and *Macodes* are all stellar jewels in this orchid constellation. Jewel orchids are terrestrial, and all have fleshy creeping rhizomes that prefer rich humus potting media. They may display luxurious, velvety burgundy or green foliage with iridescent veining, often with copper, gold, or variegated white highlights on the leaves. The patterns

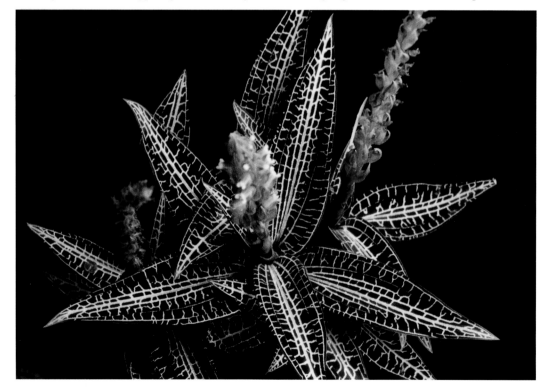

Goodyera hemsleyana

can be complex, making a cluster of leaves as impressive as a large flower from a corsage orchid.

The native home for most jewel orchids is the warmth and abundant humidity of the Philippines, India, New Guinea, and throughout Southeast Asia. Cultivated growing conditions would require a filtered-light area in your home. Terrarium culture is ideal for these plants. In the early days of orchid growing in Europe, *Ludisia discolor* (by far the easiest to grow) was a popular "stovehouse" plant, growing under garden cloches on a bench with hot, coal-stoked steam pipes underneath the bench. Moist air is a critical factor to success with these woodland terrestrials. Drafts and cold air must be avoided.

Ludisia discolor var. *nigricans*

The *New York Times* has featured *Ludisia discolor* as an easy-to-grow, apartment dweller's plant for lower light. The fleshy rhizomes contort and twist, making an unusual three-dimensional botanical sculpture. *Ludisia discolor* can become very large and showy, with as many as fifty clusters of glistening, iridescent metallic leaves.

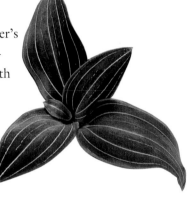

North America hosts the cooler brethren of the jewel orchids, *Goodyera pubescens* (commonly referred to as the rattlesnake plantain), along with three other native *Goodyera* species — *G. oblongifolia, G. tesselata,* and *G. repens.* All have similar but distinctive patterns. North American jewel orchids are considered wildflowers by many naturalists. They grow in clusters in deep humus-rich soil underneath pine trees or in sphagnum moss mounds in the filtered light of the forest floor.

Ludisia discolor var. *dawsonianum*

Whether you are taking a walk in the woods or you aspire to grow an exotic in the shadow of the Manhattan skyline, don't overlook the jewel orchids. They are small and quiet in their beauty; they are jewels that sparkle, even in the denial of their flowers, as diamonds in the rough.

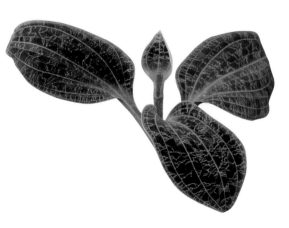

— Mariko Kawaguchi

Macodes sanderiana

A Passion for Orchids

These statements by a wide range of orchid enthusiasts—from the professional hybridizer to the orchid hobbyist—demonstrate the abiding allure of growing orchids. Many of the orchids pictured in this book were grown by these individuals.

It has been fifty-six years since a friend of mine gave me my first orchid. That same week I purchased my next orchid. In the past it was thought that you had to be a person of means in order to own orchids. I found out differently; you did not have to be wealthy to admire the beauty of these rare flowers. It was the exotic nature and unique beauty of orchids that made me feel like a millionaire. If I didn't have orchids to observe and grow, it would be like not having food on my table to sustain me.

Victor DeRosa

Orchid grower, hybridizer, Natick, Massachusetts

I have always been an impatient person; however, orchids have taught me to wait patiently and be rewarded by their beauty. Orchid time has a different set of hands on the clock. In their diversity, I can appreciate their simplicity, both aesthetically and in their ease of culture. So I was ready to begin my research for growing orchids. My life has taken many bends and twists since my first orchid plant, creating a diverse career. The right and left hemispheres of my brain are constantly exercised. I head a tissue culture lab, which offers an endless array of possibilities for producing man-made orchid varieties, as well as for boosting the populations of vulnerable species that are endangered in the wild. In vitro culture and an awareness of conservation keep my passion for this group of plants a central part of my life.

Mariko Kawaguchi

Horticultural designer, Edgartown, Martha's Vineyard, Massachusetts

I introduced myself to orchids as a kid. I noticed how unusual the lady's slipper orchids were blooming in the woods. It wasn't until Victor DeRosa and I met that I realized how special these flowers really are. His affection for the plants was contagious, and it didn't take long before I wanted to grow my own orchids, as many as I could get my hands on. Working in the plant tissue lab, propagating endangered native lady's slippers, I hope to be able to allow my children to enjoy these wonderful plants. Orchids have something to offer everyone. Their beauty and diversity are unmatched in nature.

Chris Doherty

Tissue culture lab specialist, lady's slipper enthusiast, Boston, Massachusetts

On a spring day twenty years ago, I went to the orchid houses located on the renowned Stone Estate in Marion, Massachusetts. I bought my first orchid that day—a miltoniopsis. A few months later, that orchid had died, but I had been so enchanted by its beauty that I went back and bought a dendrobium, which I still have in my collection. Now, as a commercial grower, with every orchid that leaves my greenhouse I try to pass along this love I have for one of nature's great gifts.

Stephen Sethares
Commercial orchid grower, Centerville, Massachusetts

I am a retired cardiothoracic surgeon who has spent more than fifty enjoyable years devoted to the practice of medicine. Orchids have made a wonderful hobby, and in retirement have offered a substitute for the attention to detail previously required in my profession. I am busy growing, writing, and speaking about orchids, and through the Internet I have met an interesting group of orchid enthusiasts throughout the world. I can think of no other hobby that could have given me so much pleasure.

Wilford B. Neptune
Orchid hobbyist, West Newton, Massachusetts

Why do I grow orchids? A few years ago I would go to the supermarket and bring home houseplants. Then my husband suggested it would be so much nicer if they were flowering plants. A few weeks later I went to a florist and bought an orchid plant in bloom and suddenly I got the bug. The "orchid bug," that is, and I have been a passionate orchid grower ever since.

Jeanne Usereau
Windowsill grower, Cambridge, Massachusetts

139

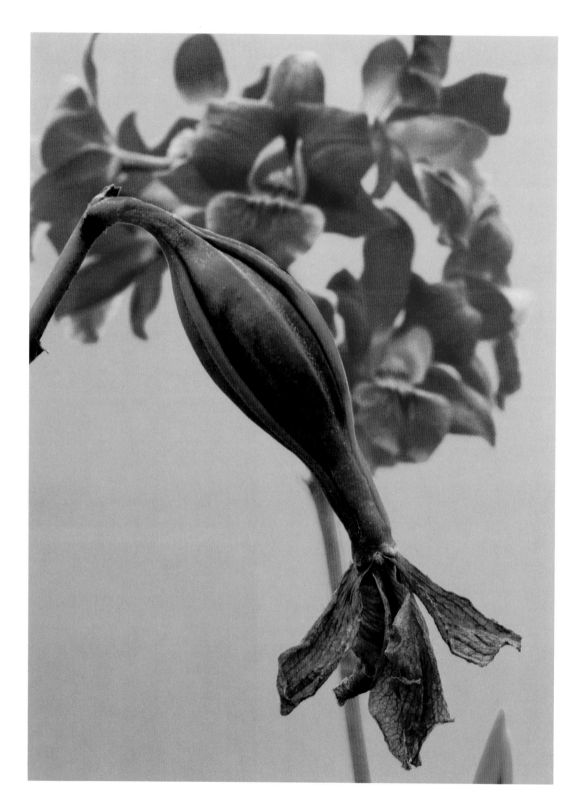

Ripening seedpod of
Epidendrum
Rhody 'Weston'.
Orchid flowers quickly decay
as soon as they are fertilized,
throwing all their energies
into the next generation.

Acknowledgments

Every book of photographs has a lot of people participating in some aspect, lending their expertise and hard work to create a successful labor of love. This book is no exception, and I am grateful to the following people for their contributions: Mariko Kawaguchi, orchid grower, hybridizer, and writer; Rosalie H. Davis, garden writer; Katherine Brown-Wing, illustrator; Glenn Engman, electronic imaging expert; Jill LeVasseur and Aimee Erickson, printers and assistants to Mr. Engman at his company, On Target, Inc.; William Field, art director and designer; Janet Swan Bush, executive editor of Bulfinch Press, Little, Brown and Company, and her colleagues Peggy Leith Anderson, Ken Wong, Ann Eiselein, and Tiffany Reed.

I also wish to thank the growers and exhibitors of the orchids illustrated on the pages of this book:

Victor DeRosa, Natick, Massachusetts

Dr. Wilford B. Neptune, West Newton, Massachusetts

Stephen Sethares, Village Orchids, Centerville, Massachusetts

Maurice Sussman, Woods Hole, Massachusetts

California Orchids, Carpenteria, California, 1997

Cape and Islands Orchid Society Show, North Falmouth, Massachusetts, 1998

Eastern Orchid Conference, King of Prussia, Pennsylvania, 1997

Garden in the Woods, New England Wild Flower Society, Framingham, Massachusetts

Longwood Gardens, Kennett Square, Pennsylvania, 1997

Massachusetts Orchid Society Show, Lexington, Massachusetts, 1997

Mountain Orchids, Ludlow, Vermont

United States Botanical Garden, Washington, D.C., 1997

Thanks for all the effort and labor. Rare orchids thank you, too.

— Béla Kalman, MFIAP/USA

Index of Orchids

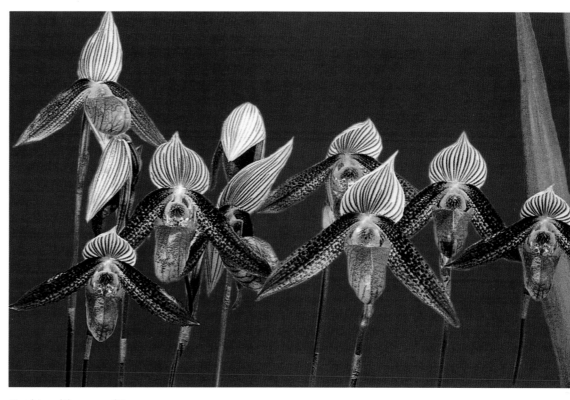

Paphiopedilum wardii

Index of
Orchid Growers

First edition

Library of Congress Cataloging-in-Publication Data

Kalman, Béla
 Rare orchids / photographs by Béla Kalman; text by
Rosalie H. Davis and Mariko Kawaguchi. — 1st ed.
 p. cm.
"A Bulfinch Press book."
Includes index.
ISBN 0-8212-2567-7 (hardcover)
 1. Orchids. 2. Orchids — Pictorial works. 3. Orchid culture.
I. Davis, Rosalie H. II. Kawaguchi, Mariko. III. Title
SB409.3.K35 1999
635.9'344 — dc21 98-38750

Bulfinch Press is an imprint and trademark of Little, Brown and Company (Inc.)

Line drawings by Katherine Brown-Wing

Designed by William Field, Santa Fe, New Mexico

Endleaves: Adapted from a collectors series of Guyana orchid stamps

Printed in Italy by Almicare Pizzi